Another London

Edited by Helen Delaney and Simon Baker
Introduction by Simon Baker
Essay by Ben Gidley and Mick Gidley

Another London

International Photographers Capture City Life 1930–1980

Tate Publishing

First published 2012 by order of
the Tate Trustees by Tate Publishing,
a division of Tate Enterprises Ltd,
Millbank, London SW1P 4RG
www.tate.org.uk/publishing

on the occasion of the exhibition
Another London
International Photographers Capture City Life 1930 – 1980

Tate Britain, London
27 July – 16 September 2012

A catalogue record for this book is available from the British
Library.

ISBN 978 1 84976 025 6

Designed by Untitled
Colour reproduction by DL Imaging
Ltd, London
Printed by Graphicom SPA, Italy

Front cover James Barnor,
Mike Eghan at Piccadilly Circus, London c.1967, printed 2010
(see no.81)

Back cover Hannes Kilian,
Piccadilly, London 1955 (see no.57)

Frontispiece Al Vandenberg, *Untitled* 1975, from the series
On a Good Day
(detail of no.99)

Measurements of artworks are given in centimetres, height
before width.

In memory of Eve Arnold (1912–2012),
Horacio Coppola (1906–2012),
Sergio Larrain (1931–2012)
and Al Vandenberg (1932–2012).

Foreword

Penelope Curtis
Director, Tate Britain

It is over sixty years since London last hosted the Olympic Games; over sixty years since many of the photographers featured in *Another London* first visited the city. In recognition of the remarkable cultural event which manifests itself at this time, Tate Britain presents a unique collection of photographs, of which London, and Londoners, are the subject.

This exhibition is the result of a set of happy coincidences: a particular collection of photographs of London, of which this selection by photographers from outside Britain forms part; and the continued support of Tate's commitment to photography by Eric and Louise Franck, who brought the collection together over 20 years. At a moment when the city is under a new level of scrutiny by visitors from abroad, the presentation of this view of London from outside could not be more timely.

Many of the photographers included in this exhibition, and in this book, treat London in terms of its inhabitants. The Londoner is as much the subject as the capital itself. In this way, the photographs remind us of anthropological surveys, and the photographer of the scientist who records without comment, but whose records tell us much about the society they show.

Here, in black and white (and quite literally so), we see a society that, only half a century later, has all but disappeared. From across the spectrum, central and marginal, established or incoming, the social strata seem strange to us now, and must have appeared just as foreign to those photographers whose incoming eyes were fresh to the nuances of British life. Whereas we are removed by the distance of time, they were removed by their lack of physical familiarity. They caught that strangeness before the British understood how strange it was, and how soon it would fade away and die.

Another London takes its title from that used by photographers Chris Killip and Graham Smith for their joint exhibition staged in 1985 at the Serpentine Gallery, *Another Country*, a title suggesting that it takes only a little distance from the centre to see things in a radically different way. Whereas Killip and Smith showed Londoners what was happening in the north of their own country, at only a few hours remove from the capital, *Another London* shows how London looked through the eyes of visitors only a few decades ago. That these visitors were also exceptional artists, already known for their innovative and perceptive imagery, makes their record all the more exceptional. Remove the photographers from their usual surroundings and their object takes on a startlingly different kind of honesty. The title was suggested by Simon Baker, who has worked so hard to bring another kind of photography, another kind of art, to the Tate collections. He has prefaced the selection of works, made in collaboration with Helen Delaney, with a short text that places these photographs within a wider cityscape. It is followed by a more discursive series of reflections by Ben Gidley and Mick Gidley, respectively based at the Universities of Oxford and of Leeds.

This selection of photographs is a part of a much larger collection that is happily going to enter Tate's collection. It will greatly enrich our holdings of both international and of British art, serving to bring the two together in the most apposite and rewarding of ways. We are grateful to the exceptional generosity of Eric and Louise Franck which enables us to show this work now and will allow us to exhibit further selections in the future. We also thank everyone who has helped bring this project to fruition.

Another London
The Eric and Louise Franck London Collection
Simon Baker

Even from the very earliest days of the medium, the history of photography has been a history of city life, from Daguerre in Paris (some of the very first photographs ever produced), to Hill and Adamson's breathtaking visions of nineteenth-century Edinburgh. It has been in the twentieth century, however, beginning in earnest with the modernist movements of the 1920s, that photography can be seen to have claimed the city as its own subject par excellence, making good the promise of an authentic account of urban experience that could be subjective and objective in equal measure. But the fact that London was the subject of neither the majority nor the best-known of these projects – the stunning accounts of Paris made by Eugene Atget, Brassaï and Germaine Krull, to name a few of many, William Klein's New York (perhaps the most influential), or Nobuyoshi Araki and Daido Moriyama's lifetimes in Tokyo – says much about London as a site within a cultural context that situated Paris as capital of the nineteenth century, and New York and Tokyo as capitals of the twentieth. But there is also, of course (whether in actuality or perception), the grey matter of London's weather:

the light essential for photography, which floods the wide-open boulevards of Paris, penetrates even the steepest high-rise avenues of New York, and illuminates Tokyo both day and night. It is an intriguing fact, in this context, that perhaps the finest photo-book ever made in London, Bill Brandt's Brassaï-inspired *Night in London*, tackles this problem head-on, making a virtue of necessity.

Eric and Louise Franck's remarkable collection of photographs of London contains some 1,200 works, assembled over more than twenty years, of which the present selection offers only a first glimpse. This achievement is made all the more significant by proving (counter to the prevailing wisdom) not only that London has been photographed extensively, but that it has been photographed by many of the twentieth-century's finest photographers: both by those famous names that one associates with the apparently more 'photogenic' streets of Paris and New York, and a wealth of brilliant and original artists from Europe (both East and West), the Soviet Union (as it was), the United States, Latin America, Africa and the Caribbean. But if the vision of London offered collectively in this exhibition is one of the eye of the outsider, whether temporary visitor or permanent settler, it is also clear that many of the London sights from the 1930s to the 1980s that it reveals will be as strange and compelling to a contemporary audience as they were to those generations of previous arrivals. For unlike Paris, fixed in the public imagination by its dominant nineteenth-century architectural character, London is a heterogeneous city that appears both ancient and modern, and has enjoyed a continuous process of change, growth and adaptation. *Another London*, however, is far more than simply a photographic account of city life in the middle of the last century: what it shows, rather, is the technical skill, sensitivity and originality of some of the world's finest photographers in the face of a subject as overwhelming, diverse and complex as London.

Another London
Overseas Photographers
View the City at Mid-Century
Ben Gidley and Mick Gidley

Doors

In 1937 Bill Brandt must have had to crouch down in order to portray a young woman cleaning a floor: the door jamb to her right and the horizontal line of the step beneath her align with the edges of the photograph, acting as a frame within a frame (no.10). Kneeling over her bucket, she looks down at the tiles she scrubs. Despite her obvious activity, the picture has a quiet, studied look. By contrast, the image that Robert Frank made more than a decade later in 1951 of a child in full flight on the left, the wide-open door of a hearse on the right, captures a split-second juxtaposition (no.46). In the picture, whether or not it was so in reality, it is as if the girl is running away from the fearsome hearse. Neil Kenlock's view, made two decades later again, in 1972, of a black woman standing by a white doorway daubed with racist graffiti ('Keep Britain White', in black paint) indicates interaction between the photographer and his subject: her left hand is extended to point to – and to point up – the offensive text (no.86).[1]

Although representative of very different photographic registers – from Brandt's modernism to Kenlock's reportage approach – each of these pictures, it could be argued, reaches towards a sense of the universal. Brandt's image was selected for *The Family of Man* (1955), Edward Steichen's major exhibition and book, which deployed photographs to stage a notion of common humanity. Steichen clearly recognised its archetypal appeal: the image featured, alongside other examples from around the world, in a sequence on women's work. Frank's photograph – one of the earliest of his works to command the kind of admiration that would become routine after the publication of his famous book *The Americans* (1959) – similarly suggests a symbolic reading: though she runs, the girl cannot ultimately escape death's wide and ever-open door. The inevitability of death, for us all, is at the heart of the picture. And the black and white, in every sense, of Kenlock's picture represents seemingly perennial racism.

Each of the three photographs, however, belongs to a specific time and place. Brandt titled his image *Housewife, Bethnal Green*, and we should notice the bright wedding ring on the woman's left hand. The drab near-uniformity of the terraced houses in Frank's receding street and the kind of car that serves

as a hearse are typical of Britain in the immediate postwar years. The racism evoked by Kenlock is obviously British, and his image – reportedly made in Balham – documents the particular manifestation of racial hostility that occurred in the period after the Shadow Defence Secretary Enoch Powell openly incited it in his infamous 'Rivers of Blood' speech of 1968. And, despite the fact that in visual content they contain few signs of their place of origin – London – all three images are of a piece with the London of their time. In all three images, whether read as documentary records or as symbolic of universal values, we can catch traces of London's particularity and of the profound changes that marked its mid-twentieth century moment.

These pictures, like the others that concern us here – all selected from a unique larger collection of photographs of London – were taken during the middle decades of the century by artists who were not native to Britain but came to its capital under a variety of circumstances. The biography of London as a metropolis, the biographies of the photographers, and the historical development of photography intertwined to create this body of work. Like the three images of doors with which we open this essay, the photographs in the collection represent a range of visual strategies and approaches, but taken together say something important about the time and the place of their making.

The Mid-Century Moment

In several ways, the London of today was made during the mid-twentieth century. Its expansion into those outer suburbs that were within easy commuting distance, especially the extensive area to the northwest of the city served by the Metropolitan Railway ('Metro-land'), was as significant a transformation of the city as the building of the Victorian inner suburbs in the previous century. The Blitz in 1940–41 saw massive destruction (as so vividly captured in Wolfgang Suschitzky's almost aerial shot from St Paul's Cathedral (no.27)), which scarred the capital, especially the East End and South London, for a generation afterwards. But in its wake, and while Britain was still at war, the nation's leading town planner, Patrick Abercrombie, was commissioned to conceive an ambitious plan for the postwar era. The resulting County

of London Plan of 1943 and Greater London Plan of 1944 proposed the creation of a series of 'New Towns' and urban villages on the outskirts of London, allowing the older centre to breathe, and linked by a concentric pattern of ring roads.[2] The plans' striking Bauhaus-style maps and aerial views of the city, made possible by the same technologies that had enabled the Blitz, framed the city in a new way and helped structure the postwar reconstruction that gave London the distinctive shape and sense of space that – despite the wave of high-rise corporate construction since the 'big bang' of the 1980s – it still retains.

In this changing landscape, the coronations of George VI in 1937 and Elizabeth II in 1953, the Blitz, Victory in Europe Day in 1945, the Festival of Britain in 1951, the arrival of the 'swinging sixties' and the street parties at Queen Elizabeth's Silver Jubilee in 1977 all remain iconic London moments. So, in a different way, does the 1948 disembarkation from the *S.S. Empire Windrush* of Caribbean people at the start of the mass arrival of postcolonial migrants. Mid-century London did not retain the dense intimacy that characterises photographs of Paris from this time. Nor was it growing upwards, like the New York celebrated in another major body of urban photography. Instead, it was spreading outwards and becoming more varied.[3]

This mid-century London has become an object of nostalgia. Moments within its moment – such as the Festival of Britain or the *Windrush* landing – have, in these early years of the twenty-first century, been memorialised, celebrated, replayed in miniature, mulled over at their anniversary times. Black and white photographs – to some present-day eyes their very tones an intrinsic component of nostalgia – carry much of the weight of this mood. The urban photography of the period permanently fixed many of the ways we imagine it, but a closer look at this body of pictures also subverts that imagining, showing a London more divided and diverse than nostalgia – so often reassuring, even comforting – suggests.

At mid-century as now, London – especially for its visitors, photographers among them – was a dynamic metropolis, a place of motion. New arrivals were awed by the multiplicity of its neighbourhoods and the intricate manners of its institutions – by what novelist Henry James had earlier termed the city's

'multitudinous life'. In 1948, declaring there was about it 'something too complex to be caught', Brandt wondered 'if anyone would ever succeed in photographing London'.⁴ Most of all, visitors were overwhelmed by the sheer press of people – the packed pubs and tea rooms, the crowd of City workers flowing across London Bridge under the brown fog of a winter dawn invoked in the 'Unreal City' of T.S. Eliot's *The Waste Land* – the hordes packed onto the buses, gathered in Trafalgar Square, or shuffling beneath a sea of umbrellas, caught in motion by the fast shutter speeds of light-weight Leicas. But photographers also sought out the moments of calm and repose, sometimes on the banks of the Thames, often in London's great parks: the moments when the flow seemed suddenly to stop.

The calm of the parks and the crush of the streets speak to London's peculiar sense of time and that of the mid-century moment: the apparent timelessness of the London pub or of the liveried hotel concierge, but the dynamic modernity, even futurity, of the lights and traffic of the West End. This peculiar temporality comes to us, as we have seen, mediated by nostalgia: the utopian futurism of the Festival of Britain moment, the clean, deco forms of the city's monumental architecture and new modes of transport seem quaint today. The almost abstract lines of the buses in pictures taken in 1930 and 1959 by, respectively, Hans Casparius (no.7) and Sergio Larrain (no.61), would have spoken then of modernity, but now appear anachronistic. On the other hand, while the buses themselves have aged, the perspectives taken by the photographers retain their original freshness.

In 1938, coming back from civil war in Spain, George Orwell deployed a series of images that eerily mirrors the content of the photographs of the time. He wrote of the 'familiar streets, the posters telling of cricket matches and Royal weddings, the men in bowler hats, the pigeons in Trafalgar Square, the red buses, the blue policemen – all sleeping the deep, deep sleep of England, from which I sometimes fear that we shall never wake till we are jerked out of it by the roar of bombs'.⁵ The roar of bombs came in 1940, and London was built anew after the Blitz, and in these photographs we can see the depth but also the fragility of that sleep, as well as the London that awoke after the war.

London has always had an anachronistic relationship to England and Britain, and to Englishness and Britishness. In this representative photographic collection, we see images of pearly kings, milk bottles on the doorstep, guardsmen in bearskins, monarchist crowds and timber-lined pubs that point backwards to an imagined old England that tourists come here to see, while the modernity of its traffic and the relative exoticism of its hippies, Black Panthers and punks suggest a London jerked out of England by war and dislocating change.

Contrasting Londons

If London at mid-century simultaneously pointed backwards and forwards, into England and out of it, it was also a city of contrasts, and these contrasts beguiled visiting photographers, who seized on or staged opportunities to present the opposites that made London the city it was. Certain images of the metropolis – the red bus, Big Ben, the bowler-hatted City gent – have come to stand for Britain as a whole. At the same time, the constant and manifold flows of people, of commodities and of cultures into and through London, has marked it out as foreign and alien. The Thames, glimpsed in so many of these photographs, carried downriver, in Joseph Conrad's words, 'the dreams of men, the seed of commonwealths, the germs of empires', and in the images, especially those featuring monuments, there is a sense of London as an imperial metropolis.⁶ But the Thames also brought the fruits of empire upriver: trade goods, of course, such as the china being so aggressively hawked in Milon Novotny's *Middlesex Market* in 1966 (no.76), but also colonial and postcolonial subjects, along with Jewish refugees and other migrants, with their new foods, their seductive markets and the ethnically marked cultural niches they made in London's geography.

London, then, for visitors from abroad, was doubly exotic: the site of the eccentric peculiarities of the English, relics of an earlier imagined moment, and a site of dark, new, cosmopolitan strangeness. London itself was an 'Olde Curiosity Shoppe', an emporium of oddities, whether represented by Brandt's tattooist's window (no.6) or Horacio Coppola's pianist incongruously at the keys among goods marked for sale (no.15), both observed in the 1930s, or by Dorothy Bohm's *Petticoat*

Lane Market, East End, London (no.65) and Lutz Dille's two boys leering at girlie pictures displayed outside a Soho strip club in the early 1960s. In the British Museum, itself literally a huge 'cabinet of curiosities', Marc Riboud's dandyish 1954 visitor eyes – and seems eyed by – one of the exhibits (no.51).

London's niche geography – the city as a web of villages, as it was represented in the maps for Abercrombie's London Plans – gave it the form of a zoo, with distinct zones and dizzying contrasts. Overseas photographers seem to have set themselves the task of 'botanising its asphalt', to use a phrase deployed by the German cultural theorist Walter Benjamin when he advocated becoming so absorbed in the city as to be able read its signs as 'naturally' as a person lost in the forest would listen for the sound of twigs breaking underfoot.[7]

Multiplicity has always been a feature of London, and street photography as a genre is often organised around juxtapositions such as that between wealth and poverty. Wolfgang Suschitzky's eye for social division was perhaps partly formed by his family's socialist milieu in Vienna; he was both taught photography and introduced to London by his sister, Edith Tudor Hart, a Communist activist. Suschitzky's East End images, made mostly during the 1930s (nos.26, 27 and 29), are truly a world away from his West End views (nos.16, 17 and 30).

Capturing societal diversity, then, has been a persistent objective for the photographers who came here. The contrast between poverty and affluence was clearly of interest to Jean Moral, whose humble flower seller (1934) is relieved of one of her bouquets by a woman who is patently a person of higher social standing (no.4), and to Ivan Shagin, a Soviet photographer who pointedly captioned one of his pictures *The poor artist* (1940). Here, one of two well-dressed young women looks back sidelong at a pavement painter's handiwork, judging him as much as his art (no.25). Social critique also marks Inge Morath's 1953 portrayal of Mrs Eveleigh Nash, a woman known at the time for her opulence – and depicted as such in an image made for Morath's comparative project on the inhabitants of Soho and Mayfair (no.48).

The concern with multiplicity became more pronounced through the mid-century period. The filling in of the holes created in the city's urban fabric after the Second World War accelerated proximity between classes; often, for example, social housing was built on bomb sites in otherwise private streets. The greater ethnic diversity of postwar London again intensified this feature. London increasingly became the habitat for what photographers captured as a series of tribes. Eve Arnold, for instance, managed in 1961 to encapsulate the life style of the new tribe of independent women office workers in her aptly titled *One of four girls who share a flat in Knightsbridge* (no.71). The later photographers often made group portraits, or worked in sequences, precisely to affirm the linkages between their subjects, their cultural identity in a world city. Some of the tribes are ethnic (Leonard Freed's Jews (nos.74–5), James Barnor's Africans (nos.66, 80, and 81)), some political (Kenlock's activists, as in his 1972 *Demonstration Outside Brixton Library* (no.85)), and some sub-cultural (Karen Knorr and Olivier Richon's 1970s punks, one sporting a T-shirt with the legend 'Destroy London' (no.95)). For foreign photographers, London was often made up of a cast of 'types' – the bobby, the pearly king, the char woman, the nanny, the hotel concierge, the busker, the blind beggar, the pavement artist – whom they often knew *before* they arrived, through the received wisdom that photographic reproduction creates. The sheer variety of the eccentric street characters captured in the 1930s by the Argentinean photographer Horacio Coppola (nos.14–15) suggests that he was inventorying such types. In one of these images, Coppola brilliantly takes a head-on vantage point: the hustler seems to draw our eyes to his fistful of money in a complicitous manner.

As we come to the end of the mid-century moment, the traditional stereotypes fall away. But new types enter the vocabulary: the punks presented by Knorr and Richon (nos.94–5) were soon to become archetypal images of London , and the recurrence across the decades of particular characters suggest that such figures embody (or are seen to embody) London's spirit of place.

The Street as Stage

If these types were theatrical characters, London itself was a stage, on which arriving photographers saw a drama unfold that was familiar even as it was exotic. London's theatricality was reflected back – for Moral, Hannes Kilian and others – in the bright lights of the West End, and in the theatres

themselves. The crowds flowing into the theatres were for several of the artists as much part of the spectacle of the city as the shows they went to see. Kilian caught perfectly the antics of two clown figures, dressed like Charlie Chaplin, as they performed for cinema queues in 1955 (no.56). Some of the photographers sought vantage points from landmarks of London's architecture that would enhance a sense of the spectacular. As we have seen, Suschitzky, who generally took his pictures at eye-level, climbed St Paul's during the Blitz so that his wide view would bring out the lateral extent of the devastation (no.27). E.O. Hoppé got high above *Billingsgate Fishmarket* (1945) in order to show the street surface bathed in early morning light (no.28). Henri Cartier-Bresson helpfully annotated one of his 1951 views 'The embankment in morning, looking east from the roof of Temple Underground Station', as if its broad survey resulted from a kind of surveillance (no.43); and a year later Elliot Erwitt looked down at a bus stop, its vertical sign standing out sharply in contrast to the blur of the car speeding by (no.42).

The photographers often staged the spectacle by framing the typically London scene with a double-decker bus, a landmark statue, a black taxi cab, a phone box, a Royal Mail post box. Some of the subjects chosen were intentionally spectacular, such as a royal wedding or the trooping of the colour, or, like V.E. Day, spontaneously became so because of the excitement of the crowds. In *The lights go up in London* (1945), Felix Man, who later pioneered colour photography for reportage purposes when he covered the Festival of Britain, positioned himself well, on the bank of the Thames opposite Big Ben and the Houses of Parliament, to record the official end to the war-time blackout, superbly capturing the lights' effulgence reflected in the river (no.31).

However, more often than not it was what went on at the edges of such spectacles that caught the photographers' attention. Cartier-Bresson first came to London to photograph the coronation of George VI, but what he chose to capture were the minor incidents among the attendant onlookers, including a well-dressed woman reclining on a bench under drizzle in Hyde Park, oblivious of the photographer's camera (no.20). When he returned to London in the 1950s, to photograph George VI's funeral, he again went for what

he famously termed 'decisive moments' among ordinary people.[8] The naturalised French photographer Izis (born Izraël Bidermanas in Lithuania), during the course of his investigations of London, sought similar ordinary scenes. In one, we focus on two anonymous women moving away from us; they wear different head-scarves decoratively commemorating the coronation of Elizabeth II (no.38). Similarly, Martine Franck, among the crowds at Queen Elizabeth's Jubilee in 1977, zoomed in on two small girls sporting colourful top hats manufactured to mark the occasion (no.96).

The Chilean photographer Sergio Larrain, in London around the time of Cartier-Bresson's second visit, took a slightly different approach. Photographer Martin Parr has described him as 'the classic street photographer', but one who goes for the moment that is 'indecisive', a master of 'half-lights, blurred impressions and off-kilter angles', and we certainly register such effects in Larrain's London images: the askance sightlines in the depiction of a nanny and pram (no.59), the sense of a dramatic incident possibly about to unfold when a policeman leans in to hear – or question – the occupants of a car (no.60).[9]

Cartier-Bresson and Larrain are examples of one of photography's preferred modes: the stroll of the *flâneur* through city streets and parks. The *flâneur*, a figure described in the writings of Charles Baudelaire and later Walter Benjamin, was a gentleman who sauntered through the city, soaking up its stimulations and experiences, thriving on chance meetings, the poetry of the unexpected.[10] Marc Riboud's images have the look of such surprising encounters (nos.51–3); his photograph of people looking through railings labelled 'DANGEROUS FENCE' intrigues because we want to know what the onlookers are possibly endangering themselves to see (no.50). In London, a distinctive form of *flânerie* emerged: photographers frequently took views from iconic London buses, especially their upstairs decks: the perspective recurs in Hoppé's picture books; Jacques-Henri Lartigue photographed his wife sitting on the top deck; and Davidson made a portrait of a conductor on his bus, the closeness of the encounter turning the subject into much more than just a type (no.73).

While many city residents are enthralled to the rhythms of the city – the daily mass commute described in T.S. Eliot's

'Unreal City' – the stroll of the *flâneur* played with these rhythms, often moving against the city's beat. Some used portraiture to represent a more exotic or strange aspect of the city. Erwitt's likeness of the popular thriller writer Eric Ambler, for example, caught in the half-light of a rainy evening, and from a certain distance, as if he might be less than fully cooperative, is like a still from a film based on one of Ambler's own novels (no.40). Ambler's 1950s era and Ambler's fictional London become synonymous with Erwitt's London in 1952. Other portraits 'work' not because their subject is known, but because they seem to embody a particular aspect of London. The likeness that Davidson made in 1960 of a young woman with a pet kitten and a bedroll on her back hints at the vulnerability of tender youth in the big city (no.67). (Davidson himself was sufficiently haunted by the anonymous youngster's image to try to find her when he returned to London in 2011.) [11]

In other cases, though, neither places nor people were the real characters in the stories that these photographers told. When Suschitzky focused his camera on *New Monument Station* (1938), the recently opened Underground stop, his true subject was the 'world's largest photograph' mounted on a placard three storeys high as a spectacular advertisement for an illustrated magazine (no.26). The picture artfully invites the viewer to reflect upon the interaction between photography and society. In botanising the asphalt, inventorying London's street types and tribes, foreign photographers took on an anthropological gaze.

Markéta Luskačová, who immigrated from Czechoslovakia to the UK in 1975, might have been speaking for many of them when she described her photography as 'a way of practising sociology of a rather odd kind'. [12] It is certainly the case that her images of destitution dramatise the social divisions of urban life, but they also achieve human intimacy (nos.90–93). The empathy born of ethnographic immersion that characterises Luskačová's pictures, like Davidson's evident rapport with the youth and the bus conductor, takes their work beyond the *flâneur*'s inventorying of types. We can speculate that the very foreignness of these artists may have aided them in seeing more sharply the peculiarities of London and its social arrangements; what was familiar to Londoners was strange for them, and their own stories of arrival and departure shaped their ways of viewing the city.

Photographers' Stories

The visual registers that characterised photography from the 1930s were not native to Britain. Certain of these artists had experienced powerful forces in the making of modern photography as both modernist art form alongside painting and sculpture and part of an expanding mass media. Dora Maar is perhaps best known as a model and muse for Pablo Picasso. However, she was an outstanding artist and photographer in her own right and shared a darkroom with Brassaï. Her evident skill with a camera is apparent in the way in which, for example, she adopted a low vantage point to look slightly upwards at a pearly king on Empire Day in 1935, allowing him to fill the frame with a kind of grandeur (no.12). Ellen Auerbach was originally schooled at the Bauhaus, the hotbed of German New Objectivity, with its stress on austere clarity and startling perspectives. This is clear in her patterned, nearly abstract view of buses, made in 1936 from a position high above them (no.23). Horacio Coppola, although he had developed his modernist style in the 1920s in Buenos Aires, where he was involved with the avant-garde publication *Martin Fierro*, honed it further in Europe during his time at the Bauhaus, and through his relationship with Grete Stern, who ran a commercial studio with Auerbach.

Illustrated magazines in the 1930s used increasingly dramatic layouts, with their pictures often arranged to tell a story. This tendency was more advanced in Germany and France than in Britain; we can see this, for example, in Cartier-Bresson's 1937 coronation images, taken on assignment for *Ce Soir* magazine. These magazines were platforms for the popularisation and domestication of important components of the mid-century modern aesthetic. Several of the photographers here were participants in this development, bringing cross-Channel innovation to these islands as they fled the turmoil on the continental mainland, part of a wave that also included the publisher Walter Neurath (founder of Thames & Hudson) and the photographers Kurt Hutton and László Moholy-Nagy, who collaborated with Mary Bennedetta on the innovative 1936 photo-text *The Street Markets of London*. Felix Man is exemplary of this: he was prominent in German photo-journalism before escaping the Nazis, and in 1934, immediately after his arrival in the UK, co-founded, with another exile, Stefan Lorant, the

Weekly Illustrated, and went on to work for *the* major mid-century British outlet, *Picture Post*. Postwar, *Picture Post* became internationally popular and began to commission overseas photographers, such as the young Marc Riboud, who came from France in 1954 to take on assignments in London and Leeds. At the same time, the American and French magazines still sent photojournalists here, such as Edouard Boubat, staff photographer for the Parisian magazine *Réalités* in the 1950s.

The significance of the illustrated journals highlights the fact that each of the photographers was functioning in a particular political economy of distribution and publication. Some were abroad independently with sufficient means to survive alone; some were on commission for, or regularly employed by, illustrated journals; and, among the various other contexts for their work, at least one (Inge Morath, an Austrian native and ultimately an American citizen) was in a short-term apprenticeship to a London photographer. Hoppé, born in Germany in 1878 and a generation older than most of the other artists discussed here, was well-established enough as a photographer to be able, from 1932 onwards, to compile, publish and sell a series of books containing views of his adopted city. The self-taught Lartigue was quintessentially independent, and such images as his *Bibi in London* (1926), which depicts his wife in a typically London setting, might be viewed as part of his autobiography as well as a contribution to the documentation of the city at a particular time (no.1). After the war, such figures as Robert Frank, Eve Arnold, Lutz Dille (born in Germany but a Canadian citizen, who originally arrived to make a film exclusively about Speakers' Corner), and, later, Al Vandenberg, all came to London independently to make work.

James Barnor, by contrast, may have lost some of his autonomy on his London arrival in 1959. He had made his Ever Young portrait studio a success story in pre-independence Accra, yet when he journeyed to Britain as a photography student, it was akin to starting out again. But he maintained some of the international contacts he had established from Ghana and was soon frequenting the London office of *Drum*, the magazine that served as Africa's *Picture Post*. There is a sense of privileged access in his portrait of charismatic heavyweight Muhammad Ali in training for his fight with Brian London (no.80), and

his dynamic depiction of the popular Ghanaian broadcaster in *Mike Eghan at Piccadilly Circus* (1965) captures the exuberance, familiar to any new arrival, of having the city literally and metaphorically at one's feet (no.81).

The increasing professionalisation of the photographic medium after the war saw the rise of picture agencies, for which several of the overseas photographers worked. Magnum, the co-operative photojournalist agency founded in Paris and New York in 1947 by Cartier-Bresson, Robert Capa, George Rodger and David 'Chim' Seymour, demanded that magazines respect the integrity of the image as framed by the photographer, whom it insisted must be given proper credit, and its high membership standards were set by photographer peers. Many of the artists here became members of Magnum. Eve Arnold, for example, was the first woman member, and several key figures – including Elliot Erwitt and Marc Riboud, who both served as president, and Martine Franck in the 1970s – became mainstays of the co-operative's organisation. Magnum had no over-riding style – indeed, it took pride in its photographers' individuality of vision – but its stance, generalised by early member Ernst Haas as an extraordinary 'fascination' with 'the constant flux of life', was clearly in tune with that taken by these overseas photographers in London.[13] Elsewhere, Rene Groebli worked for the London office of the Black Star agency between 1951 and 1954. Later, during the early 1970s, Kenlock was picture editor for *Root* magazine and official photographer to the UK Black Panthers; and Martine Franck, during the period at which she took the Jubilee image and other pictures here, was a founder-member of the Paris-based Viva Agency. Only as Britain left the mid-century moment did state funding and national purchasing policies create a political economy that enabled photographers to relate to their public differently: Dorothy Bohm, represented here by work made in the 1960s, went on to co-found London's Photographers' Gallery in 1971, while Markéta Luskačová's work was supported by the Arts Council Collection.

The Non-Native Gaze

The photographers coming to London for different reasons had varied relationships with Britain. Some settled and became naturalised UK citizens, some were in London as

refugees seeking sanctuary, some en route to another home, some on short-term assignments, still others visiting as tourists. Hoppé migrated to London in the first years of the twentieth century and naturalised in 1912. When Brandt came to the city in 1931, he was decidedly cosmopolitan, and in photographic terms had absorbed much from Brassaï in Paris. His ominous *Footsteps coming nearer* (no.9) for his book *A Night in London* (1938) emulates Brassaï's *demi-monde* work for his own book *Paris de Nuit* (1933). Suschinsky, born in Vienna, fled to England in 1935 and became a citizen in 1947. Ellen Auerbach, who also escaped the Nazis, spent most of 1935–6 in London, but was refused leave to stay and moved on to the United States. Bohm came from Germany in 1939 to study photographic technology, and stayed. For many of them, the view of London was not a tourist's gaze, but an 'exile's eye'.[14] These photographers' journeys to Britain were emblematic of immense movements of people across Europe in the middle of the twentieth century – movements shaped by fascism, war and genocide.

Izis and Milon Novotny, by contrast, came to London with specific projects in mind: to create images for picture books on London to be published in their home cities, Paris and Prague, respectively. Izis brought to London something of his depiction of his home city. Paris, perhaps caught most characteristically in his collection *Paris des Rêves* (1950), is frothy, a veritable 'gay Paree', so it is perhaps not surprising that his London, presented in a parallel publication with its title translated as *Gala Day: London* (1952), is one of carousels and dodgem cars (no.37). To the novelist Henry Green, who wrote the caption for Izis' image in *Gala Day* of a man blowing bubbles, one of his eyes circled by a delicate bubble miraculously caught there, the picture was subtle enough to suggest the transmission of thought itself (no.39). The smoky interior of a Soho bar depicted in 1955 by Willy Ronis, most renowned for his archetypal depictions of the French capital, has such atmosphere that it could just as easily be a Parisian scene (no.54).

Certain of the New World photographers reveal similar tendencies. Leonard Freed gained much of his earliest individual recognition as a photographic artist by exhibiting in London, but the sensibility he brought to London came from New York.

Deeply interested in the Jewish cultures of his home city, and also alert to ethnic tensions in US society (he would later undertake a project on police brutality against African Americans), the images he made in London in 1971 often offer playful representations of the experience of a minority, even a minority within a minority, whether the Lubavitch Hassidic community (nos.74–5) or rock-festival revellers making fun of the police (no.84).

Later, photographers who came to be rooted in London were emblematic of other journeys. Neil Kenlock was born in Jamaica but his parents moved to Britain as part of the great postwar flows from the corners of the British Empire to the colonial metropolis, and he joined them a decade later. According to Mike Phillips, a writer who also came to London from the Caribbean as a child during this period, Kenlock's images take a perspective from inside the emergent black community, which was the intended audience for the images.[15]

Al Vandenberg – who in coming to settle and work in London was apparently seeking release from what he saw as the commercial pressures of New York – nevertheless held on to what several commentators have seen as a characteristically 'American' style. He presents oddly assorted Londoners with the direct, level and thoroughly 'democratic' eye that we associate with such photographers as Walker Evans (nos.97–9).[16] Usually depicted with a wall or window behind them, which prevents the eye from moving on, Vandenberg's people seem to have arranged themselves for the camera, and – as is so often the case in Evans' pictures – we note unifying visual patterns within the frame. In the picture of two standing girls, one white the other black, we spot similar scarves, contrasting black and white shoes, matching hats at virtually the same jaunty angle (no.97). Irving Penn – an American who in contrast to Vandenburg chose to embrace the opportunities inherent in such commercial work as advertising – when making portraits often removed his subjects from their own environments the better to study the essential embodiment of their personalities. Hence, his two cleaning ladies, caught in natural light against his trademark neutral background, stand out as statuesque (no.34). But at the same time, in their buckets, in their clothes and sweat, and in the lines of a lifetime of labour, they have carried their London locale into the studio.

Sometimes, the legacy of earlier London photographers – or contemporary native ones – exerted an influence on t hese overseas artists. The landmark nature of Robert Frank's *The Americans* means that we now recognise that, like Vandenberg decades later, he was much in awe of Walker Evans. But in his classic 'Statement' for *U.S. Camera Annual* (1958), Frank said 'The work of *two* contemporary photographers, Bill Brandt ... and ... Walker Evans ... influenced me'. In fact, we do often see in the work of both men – for example, Brandt's *Footsteps coming nearer* (no.9) and Frank's running child (no.45) – an intimation of a story yet untold.[17]

Markéta Luskačová became deeply engaged with the British documentary scene soon after her arrival from Czechoslovakia. Her interest in pressing societal problems is evident in her 1976 studies of derelicts in the East End, such as *Woman and man with bread, Spitalfields* (no.92). In fact, in these works, Luskačová depicts some of the very same people, and with similar directness, as those photographed by Don McCullin, best known for his coverage of war zones, around the same time.[18]

The photographic gaze and the distinctiveness of mid-century London meshed together and shaped each other. To take just a single example, one of Hoppé's London books, *The London of George VI* (1937), was titled to celebrate the accession of George VI after the furor that had marked the recent abdication of Edward VIII over his liaison with the divorcée Wallis Simpson. Its title page carries a double portrait of the new king and his queen, adjacent to a frontispiece v iew of the gates into Buckingham Palace: a book devoted to London scenes opens onto the entrance to the Royal Family's London residence at the outset of their reign. The publication both cashed in on the extended topicality of royal affairs – the public anxiety over living under 'three kings in one year' – and constituted part of the orchestrated official normalisation of the succession of George VI (who was crowned on the very day originally scheduled for the coronation of Edward VIII). And this London book enabled the re-issue of Hoppé's *A Camera on Unknown London*, a compilation first published by the same company a year earlier. Both books, moreover, had as a key selling point the fact that their images were arranged along the bus routes radiating from Piccadilly, with precise travel instructions (including the nearest Underground station) printed by each photograph – a particularly useful feature in the case of *Unknown London*, with its depictions of such 'hidden sights' as 'the oldest tobacco shop', the quarters of the tattoo artist earlier photographed by Brandt, and the obscure gravestone of the extraordinary clown Joseph Grimaldi, who had died in 1837.[19]

If today's London was made in this mid-century moment, it was partly formed through these extraordinary images. Just as the *flâneur*'s detached reflection on the city gave visibility to the distinctiveness of urban life, Hoppé's books *made* London as much as they were made by it. The practice of street photography mediated between London as a messy, complex, living space on the one hand, and particular ways of seeing on the other, to create a very specific spirit of place. These ways of seeing, if not unique to overseas photographers, characterise much of their work. In turn, we now see the city through their eyes. The London in this body of work is 'another London', but it is also one that we recognise.

Endnotes

1 Further information about these photographers, and about others discussed here, can be found in the biographical notes.

2 J.H. Forshaw and Patrick Abercrombie, *County of London Plan*, London 1943; Patrick Abercrombie, *Greater London Plan*, London 1944.

3 Much information on urban photography, especially in these cities, may be found in Colin Westerbeck and Joel Meyerowitz, *Bystander: A History of Street Photography*, Boston, New York, London 2001. See also, among many other texts, Julian Stallabrass, *Paris Pictured: Street Photography, 1900–1968*, London 2002; Max Kozloff, *New York: Capital of Photography*, New Haven and London, in association with The Jewish Museum, New York 2002; and Mike Seaborne, *Photographers' London, 1839–1994*, London 1995.

4 Brandt, quoted in Seaborne, *Photographers' London*, p.10.

5 George Orwell, *Homage to Catalonia*, London 1986, p.187.

6 Joseph Conrad, *Heart of Darkness*, Harmondsworth 1973, p.29.

7 Walter Benjamin, *Charles Baudelaire: A Lyric Poet in the Era of High Capitalism*, London 1983, p.36.

8 Henri Cartier-Bresson, *The Decisive Moment*, New York 1952, the Introduction to which is reprinted in Nathan Lyons, ed., *Photographers on Photography*, Englewood Cliffs, NJ, in association with George Eastman House, Rochester, NY 1966, pp.41–51.

9 Parr, in Martin Parr and Gerry Badger, *The Photobook: A History*, London, 2004 & 2006, Vol. 2, p.102.

10 For more on the *flâneur*, see Benjamin, as cited above.

11 See http://www.guardian.co.uk/artanddesign/2011/apr/25/us-photographer-seeks-british-girl (accessed 24 November 2011)

12 Luskačová, as quoted in George Walsh *et al*, *Contemporary Photographers*, London 1982, p.462.

13 Haas, as quoted by Jean Lacouture, in his contribution to William Manchester, *In Our Time: The World as Seen by Magnum Photographers*, London 1989, p.49.

14 This was the title of an exhibition of Suschitzky's work at the Scottish National Portrait Gallery, Edinburgh; see Duncan Forbes, *An Exile's Eye: The Photography of Wolfgang Suschitzky*, Edinburgh 2002.

15 Mike Phillips, 'Introduction', *Roots to Reckoning: The Photography of Armet Francis, Neil Kenlock and Charlie Phillips*, London 2005, p.5.

16 There is much commentary on the Americanness of the 'straight tradition' and its relation to democratic ideals, for example Mick Gidley, *Photography and the USA*, London 2011, chapter 4.

17 Robert Frank, 'A Statement', as reprinted in Lyons, ed., *Photographers on Photography*, p.67.

18 For comparison, see Don McCullin, *In England*, London 2007, pp.163–7.

19 E.O. Hoppé, *The London of George VI*, London 1937. The contemporary account of the abdication crisis published in 1941 by Robert Graves and Alan Hodge, *The Long Weekend: A Social History of Great Britain 1918–1939*, New York and London 1994, repeatedly uses 'the three kings' phrase (pp.346–65). Hoppé, *A Camera on Unknown London*, London 1936, as reissued in 1937, picture numbers 38, 47, and 18.

I.
Jacques-Henri Lartigue

Bibi in London 1926, printed c.1980
Photograph, gelatin silver print on paper 16.9 x 36

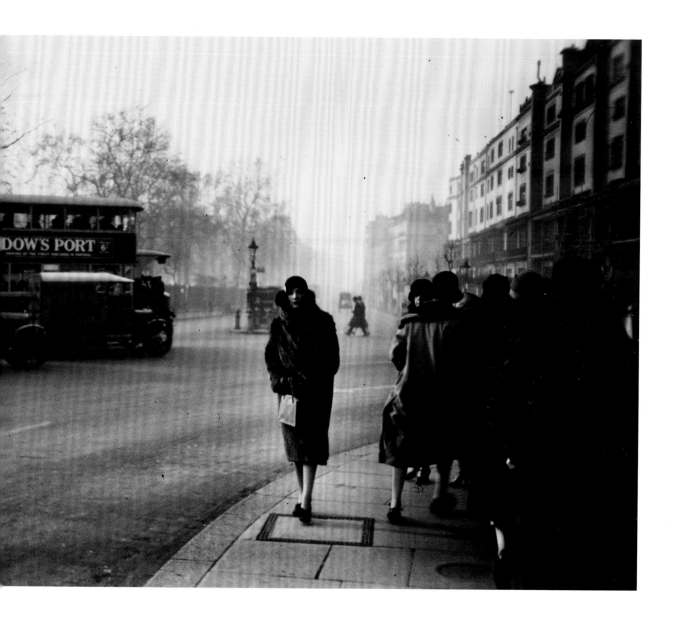

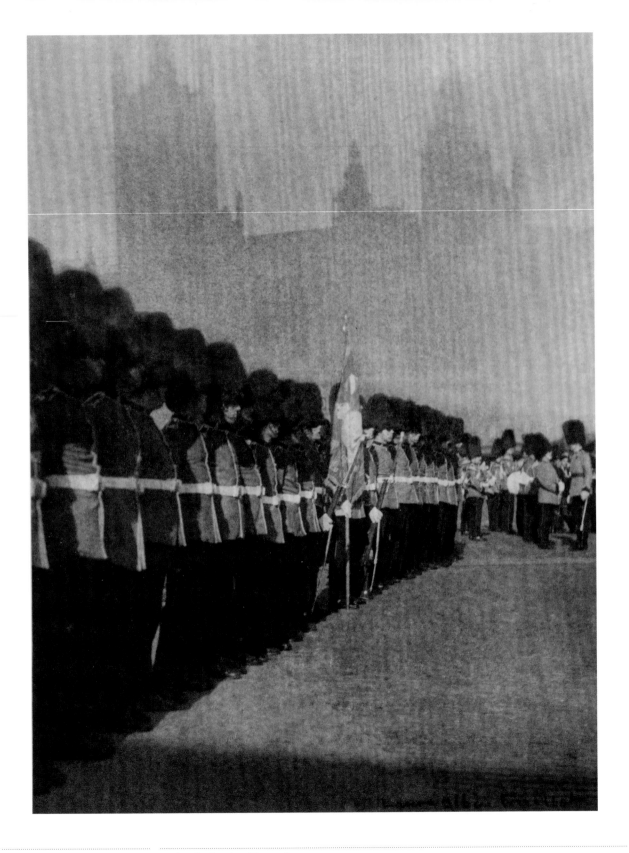

2.
Laure Albin-Guillot

London, the changing of the guards c.1930–5
Photograph, fresson print 29 x 22

3.
E.O. Hoppé

Calmly sitting on the parapets of her mighty bridges 1932
Photograph, gelatin silver print on paper 13.9 x 9.2

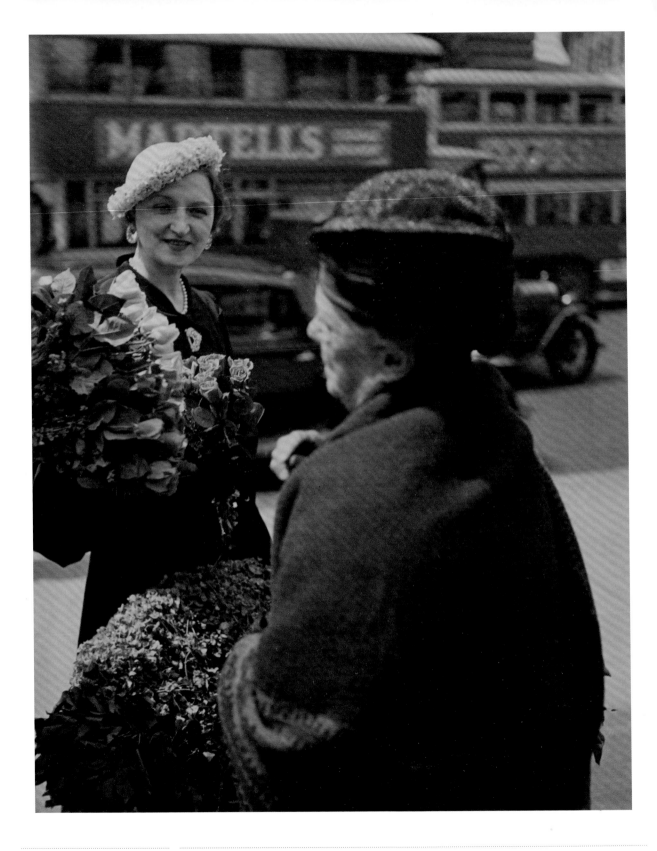

4.
Jean Moral

Flowers in Piccadilly 1934
Photograph, gelatin silver print on paper 28.8 x 22.6

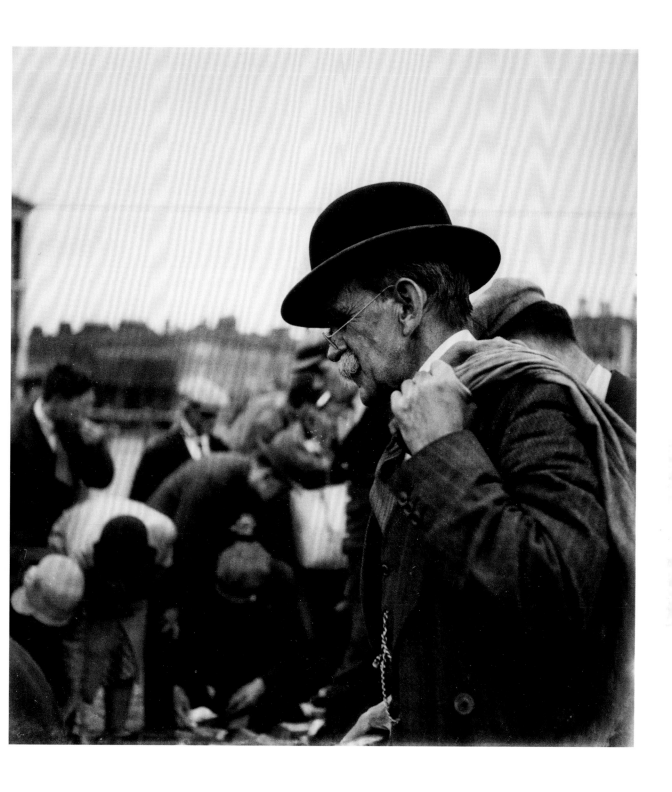

5.
Hans Casparius

Portobello Road Market, London 1930, printed 1970s
Photograph, gelatin silver print on paper 20 x 18.9

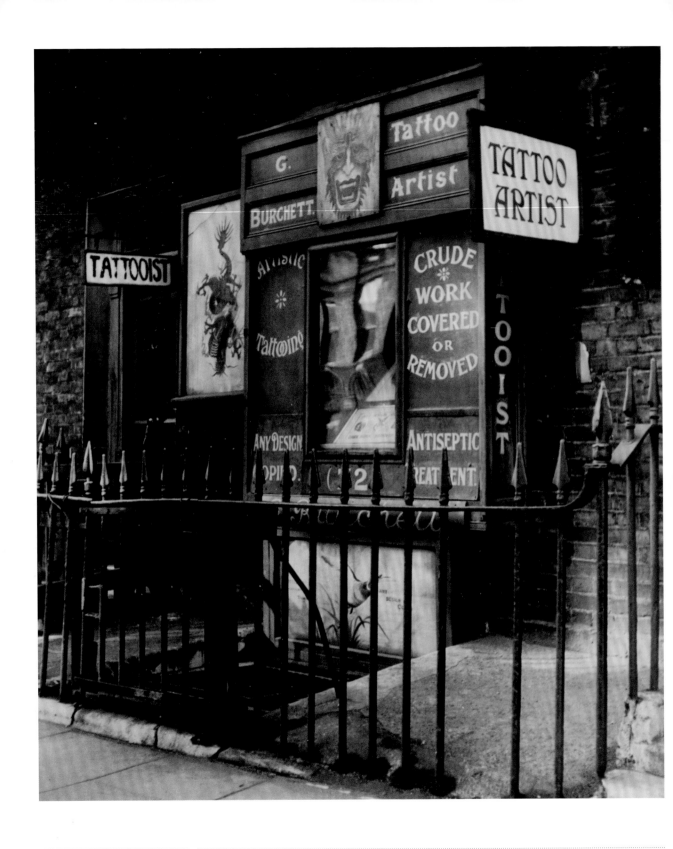

6.
Bill Brandt

Tattooist's window in Waterloo Road c. 1930
Photograph, gelatin silver print on paper 22.9 x 19.4

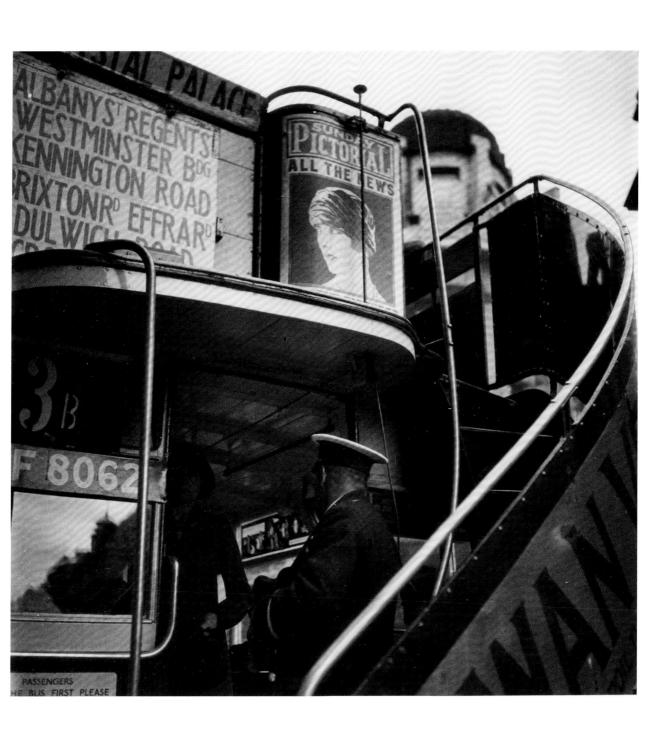

7.
Hans Casparius

London 1930, printed 1970s
Photograph, gelatin silver print on paper 21.5 x 21.5

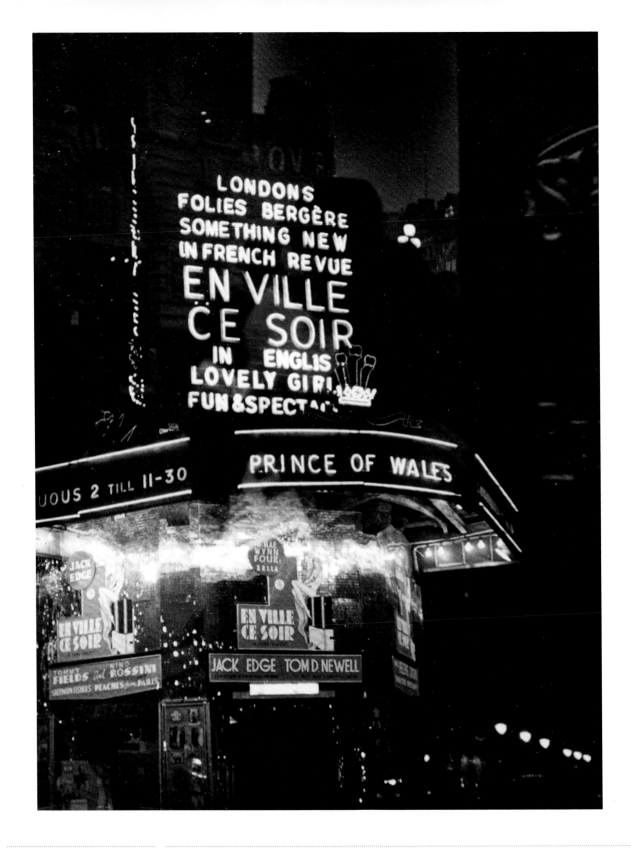

8.
Jean Moral

London at Night 1934
Photograph, gelatin silver print on paper 29.9 x 22.5

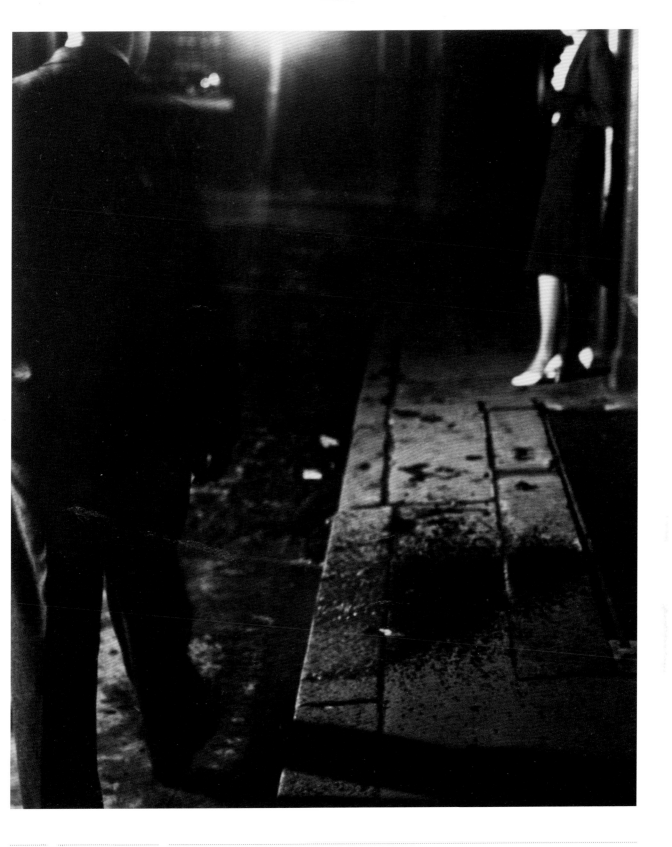

9.
Bill Brandt

Footsteps coming nearer 1933–6
Photograph, gelatin silver print on paper 34.3 x 28.9

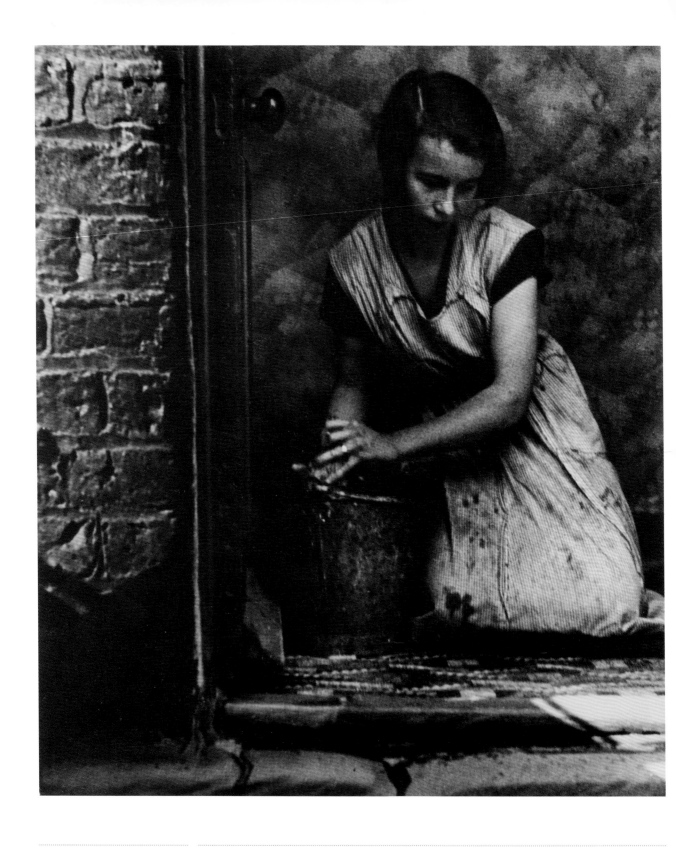

10.
Bill Brandt

Housewife, Bethnal Green 1937, later print
Photograph, gelatin silver print on paper 34 x 29

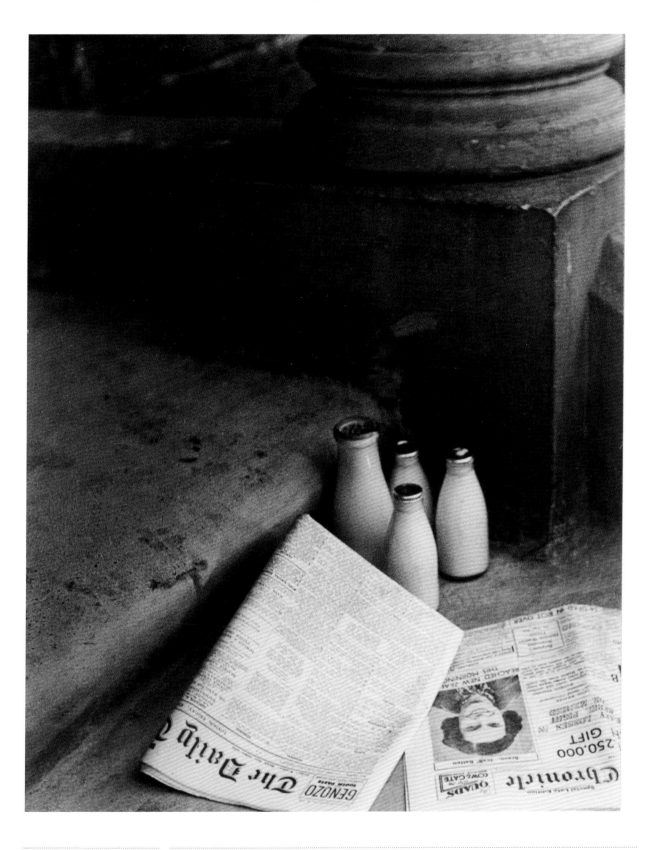

11.
Bill Brandt

Early morning on the doorstep c.1930–9, later print
Photograph, gelatin silver print on paper 37.2 x 29.2

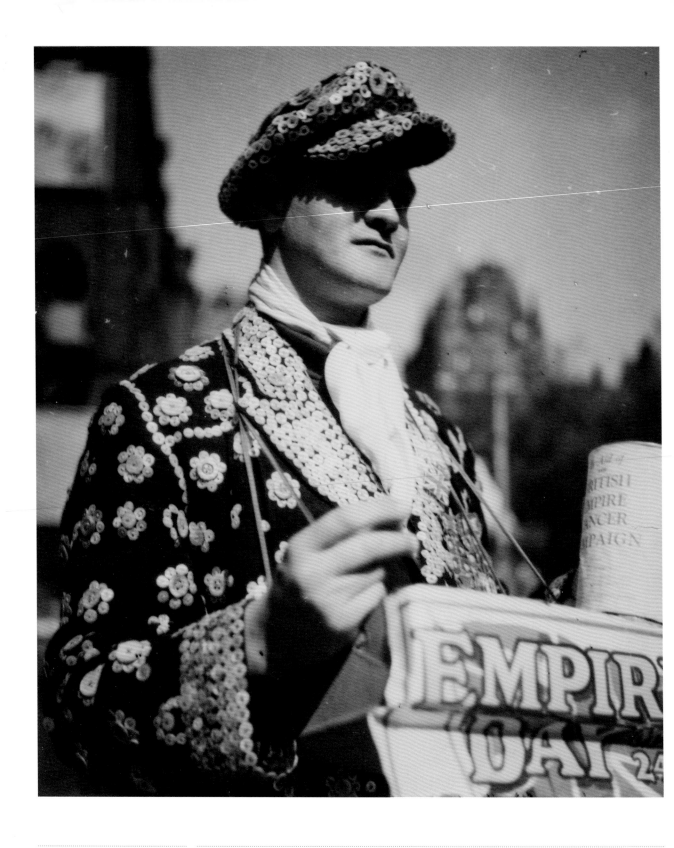

12.
Dora Maar

Pearly King collecting money for Empire Day 1935
Photograph, gelatin silver print on paper 27.3 x 23.5

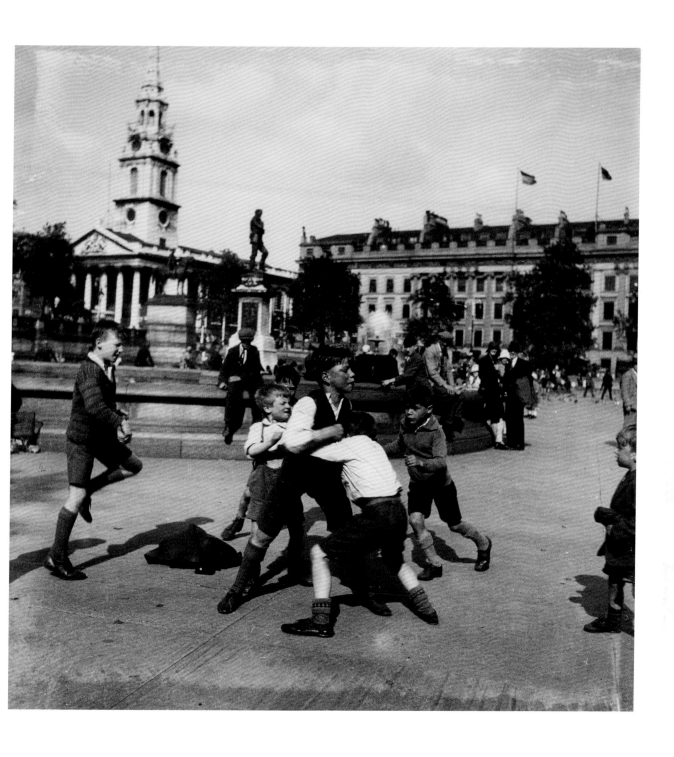

13.
Hans Casparius

Trafalgar Square c.1929–30, printed 1970s
Photograph, gelatin silver print on paper 19.8 x 18.9

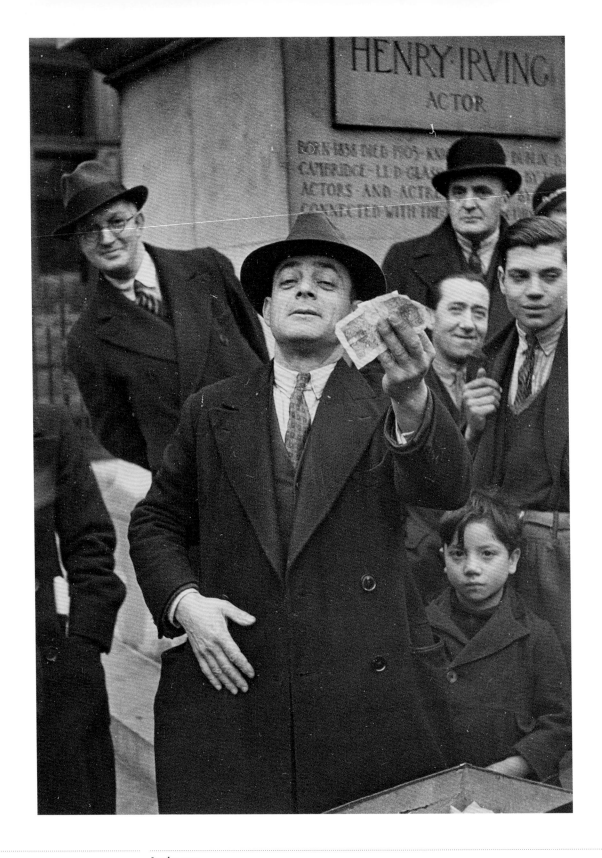

14.
Horacio Coppola

London 1934
Photograph, gelatin silver print on paper 20.4 x 14.4

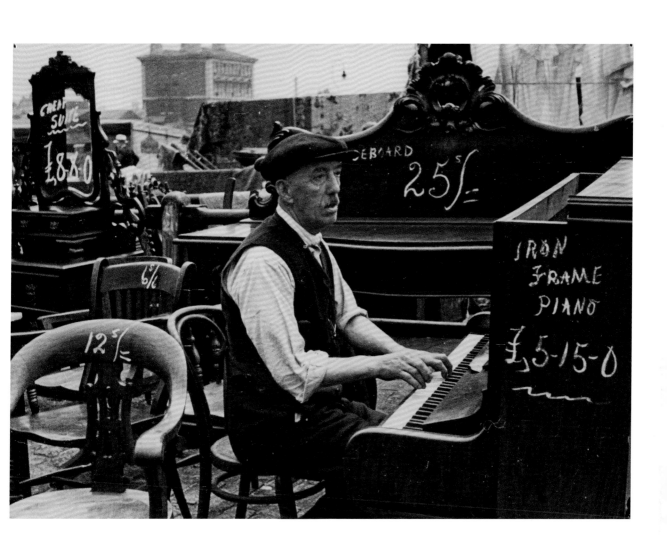

15.
Horacio Coppola

Pianist, London 1934
Photograph, gelatin silver print on paper 14.7 x 19.9

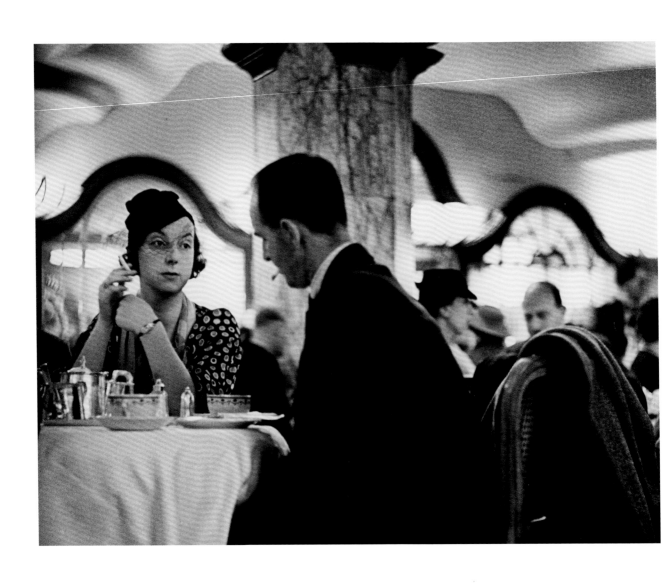

16.
Wolfgang Suschitzky

Lyons Corner House, Tottenham Court Road, London 1934, later print
Photograph, gelatin silver print on paper 39.5 x 49

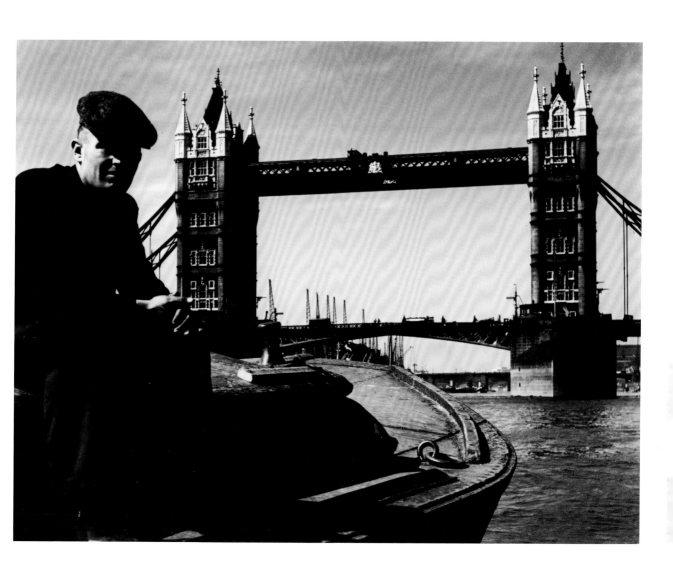

17.
Wolfgang Suschitzky

Tower Bridge, London 1934, printed 1998
Photograph, gelatin silver print on paper 29 x 37.2

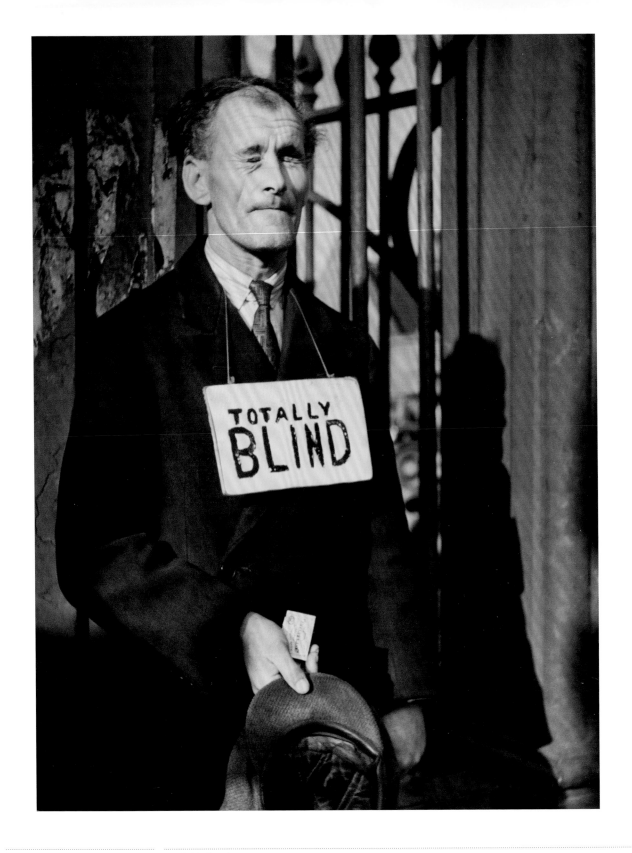

18.
Herbert List

Totally blind 1936
Photograph, gelatin silver print on paper 29.9 x 23

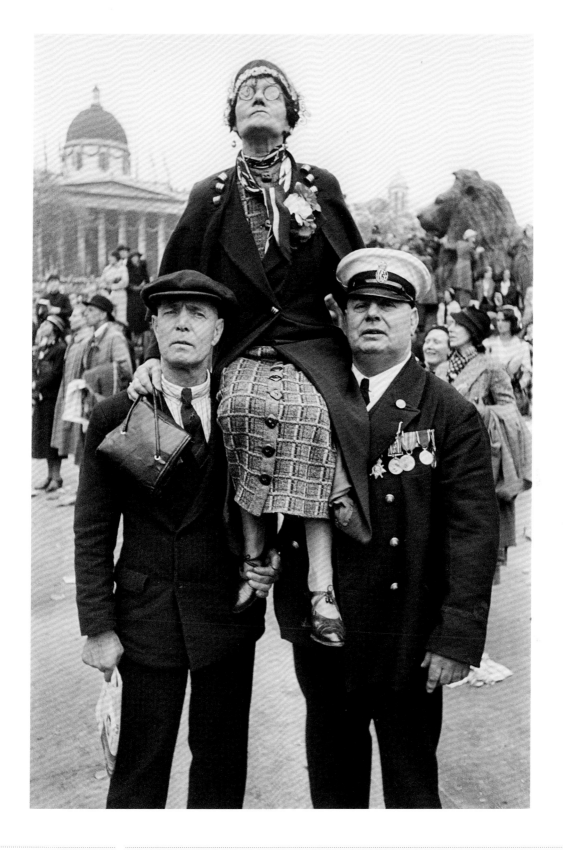

19.
Henri Cartier-Bresson

Waiting in Trafalgar Square for the coronation parade of King George VI 1937, later print
Photograph, gelatin silver print on paper 44.7 x 29.7

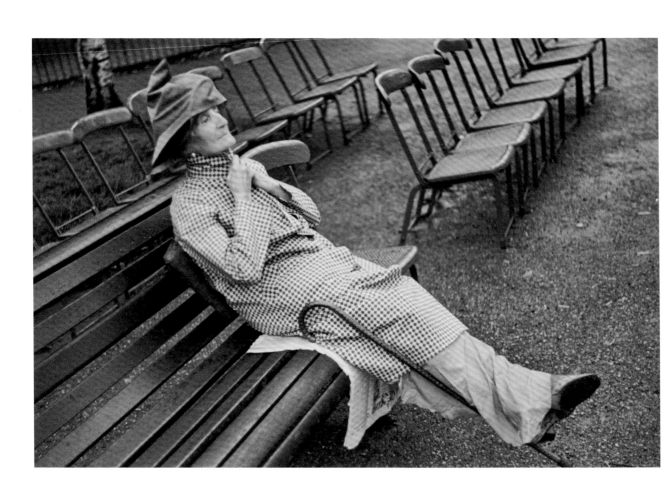

20.
Henri Cartier-Bresson

Hyde Park in the grey drizzle 1937, later print
Photograph, gelatin silver print on paper 24 x 35.8

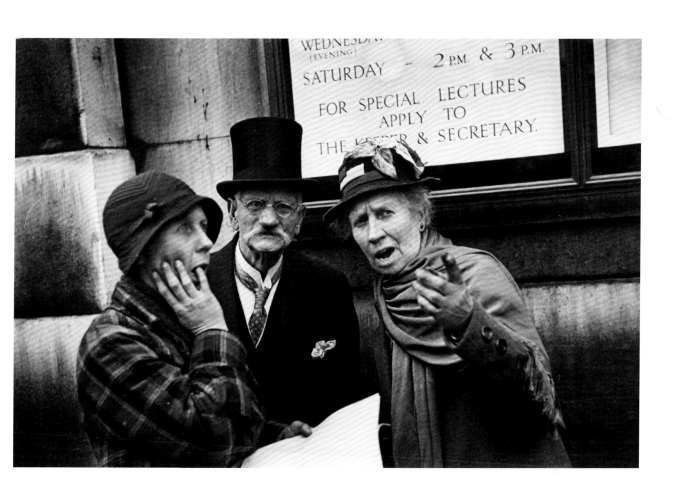

21.
Henri Cartier-Bresson

Coronation of George VI, 12th May 1937 1937, later print
Photograph, gelatin silver print on paper 23.9 x 35.4

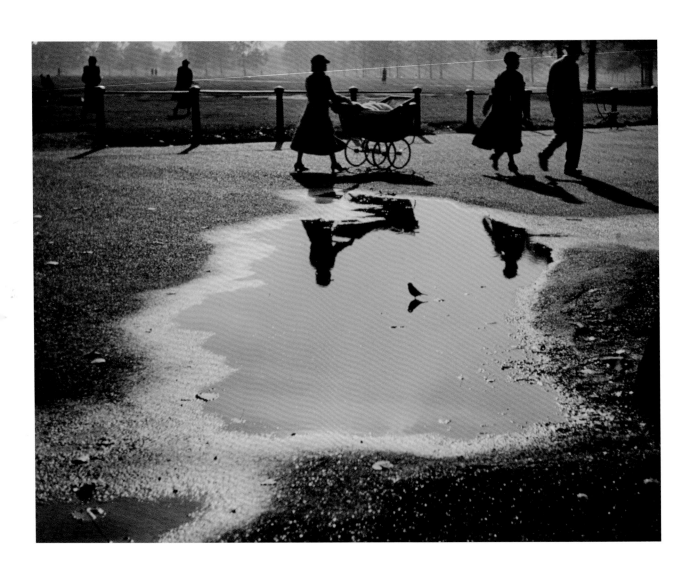

22.
Herbert List

The bird, Hyde Park, London 1937
Photograph, gelatin silver print on paper 22.9 x 29.2

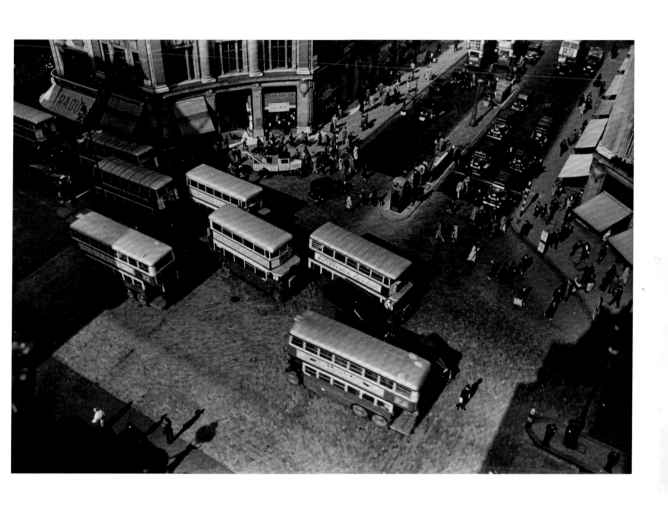

23.
Ellen Auerbach

London 1936, later print
Photograph, gelatin silver print on paper 26.5 x 39.2

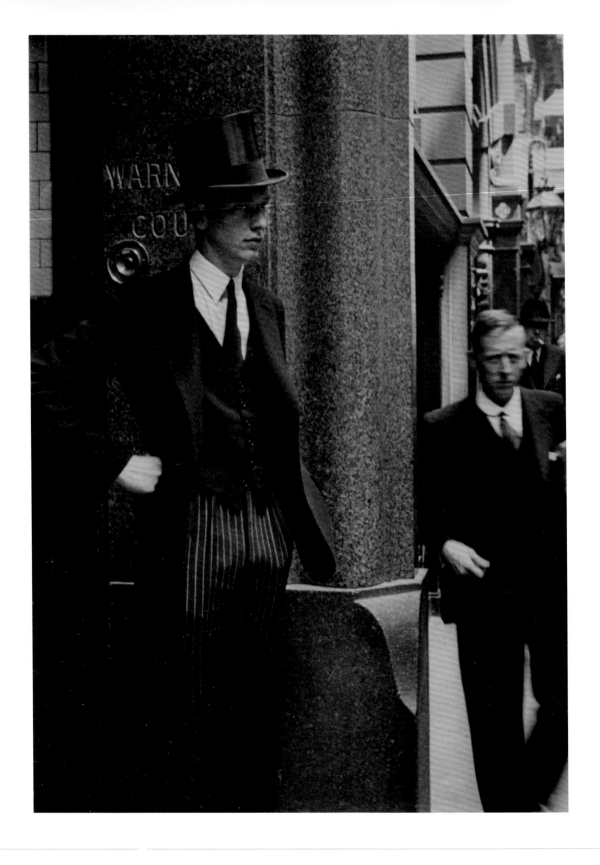

24.
E.O. Hoppé

London Stock Exchange, a typical young businessman 1937
Photograph, gelatin silver print on paper 21.3 x 15

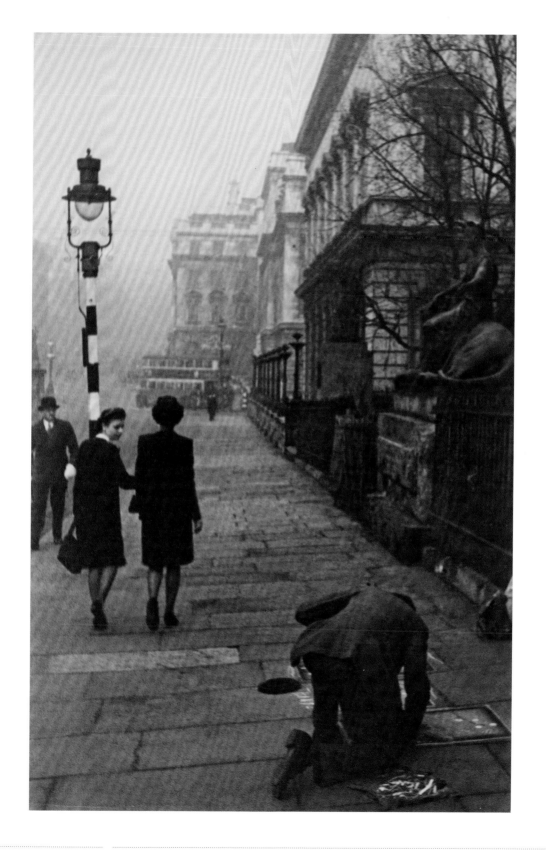

25.
Ivan Shagin

The poor artist, London c.1945–55
Photograph, gelatin silver print on paper 46.4 x 29.2

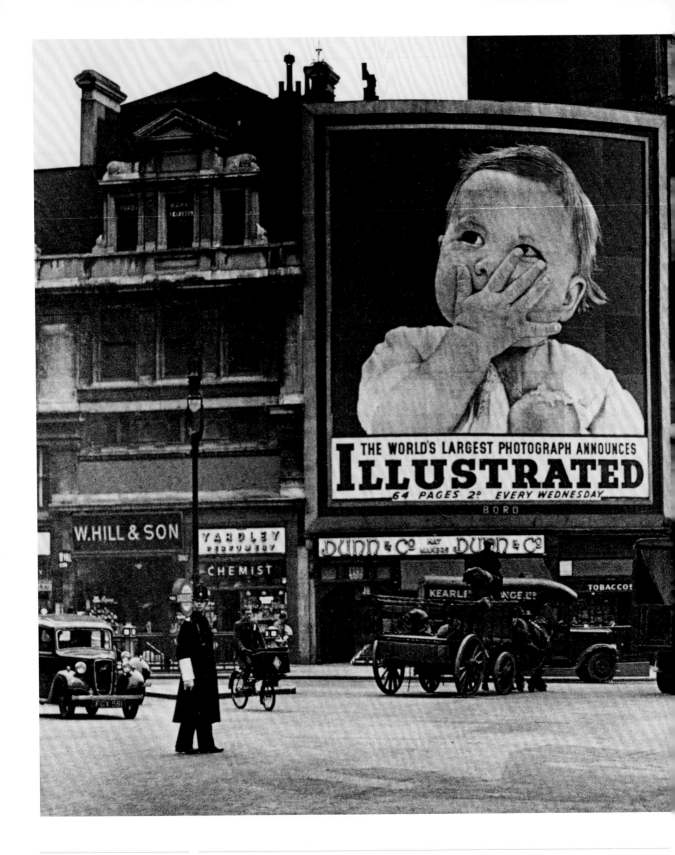

26.
Wolfgang Suschitzky

Near Monument Station, London 1938, printed 1998
Photograph, gelatin silver print on paper 29.1 x 37.5

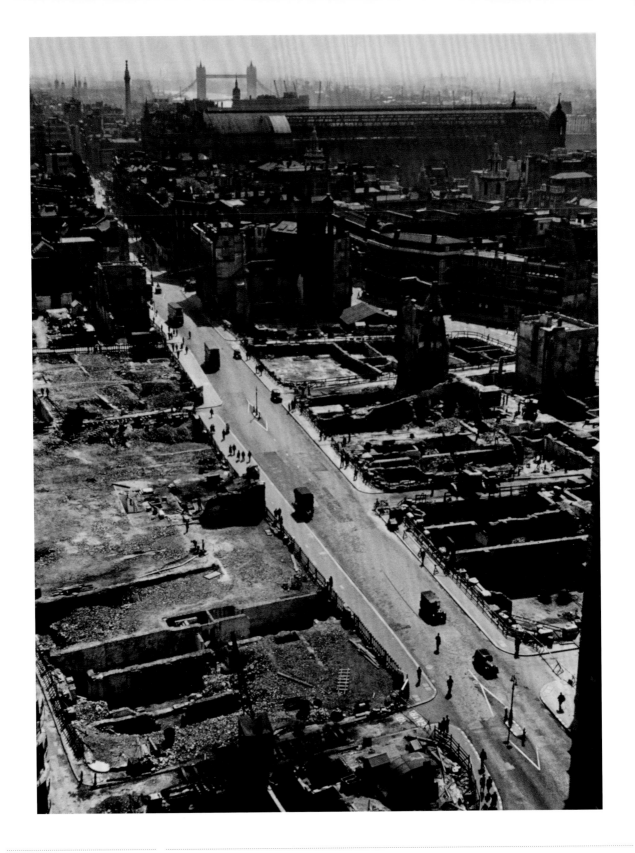

27.
Wolfgang Suschitzky

View from St Paul's Cathedral, August 1942 1942, printed 1998
Photograph, gelatin silver print 37.5 x 29

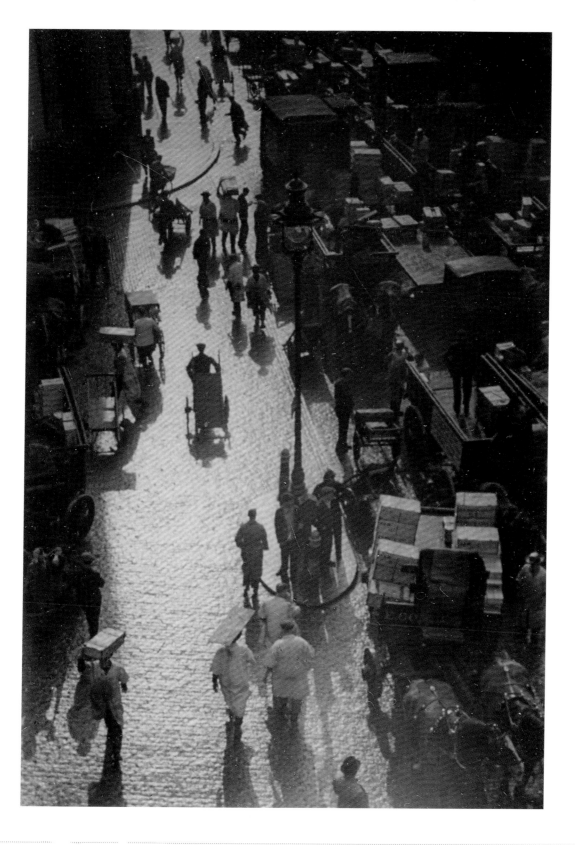

28.
E.O. Hoppé

Billingsgate Fishmarket, East London 1945
Photograph, gelatin silver print on paper 17.5 x 12.3

29.
Wolfgang Suschitzky

London, Stepney 1940
Photograph, gelatin silver print on paper 22.5. x 28.2

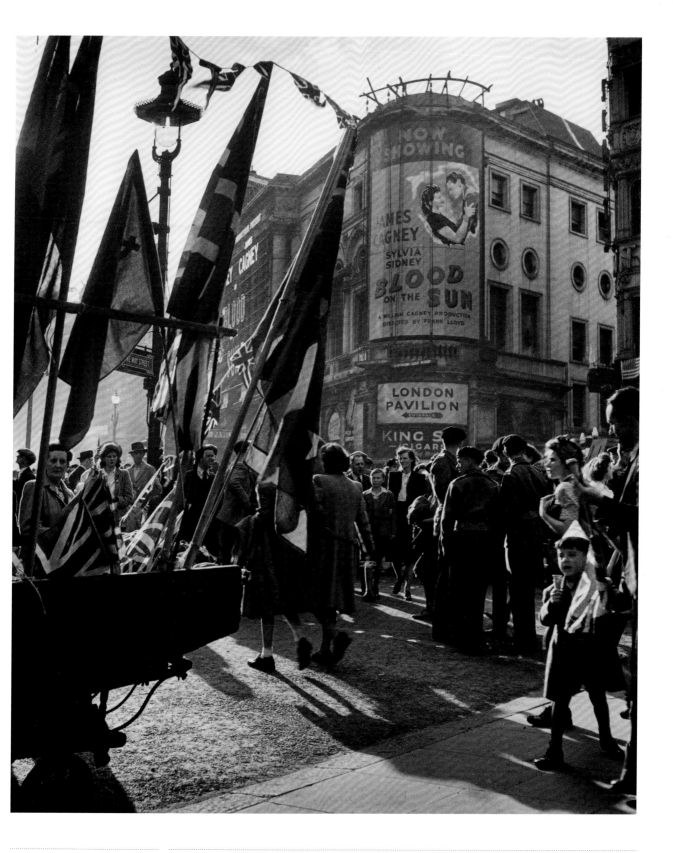

30.
Wolfgang Suschitzky

V.E. Day, Picadilly, May 1945 1945, printed 1998
Photograph, gelatin silver print on paper 35.3 x 29.1

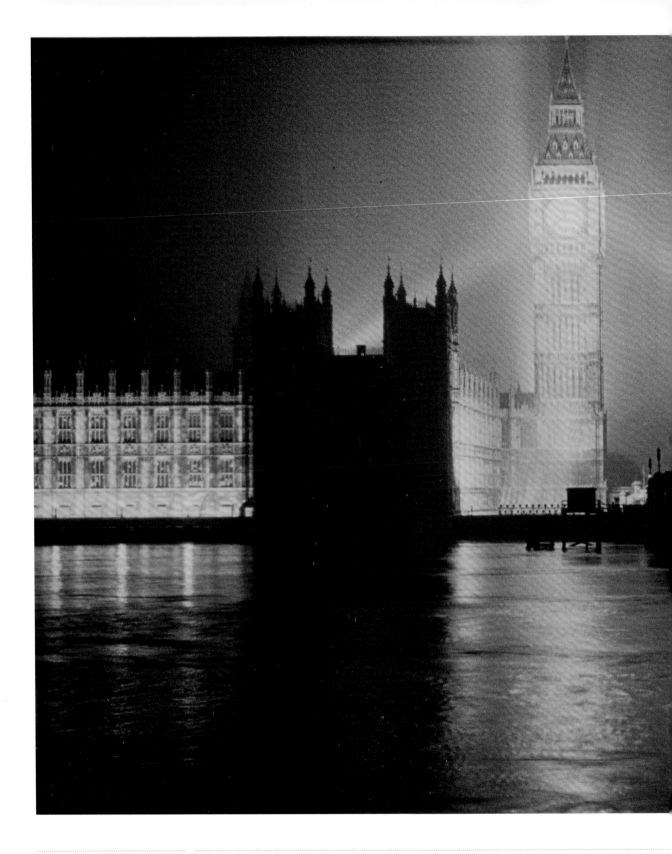

31.
Felix Man

The lights go up in London 1945
Photograph, gelatin silver print on ferrotyped paper 18.3 x 25.5

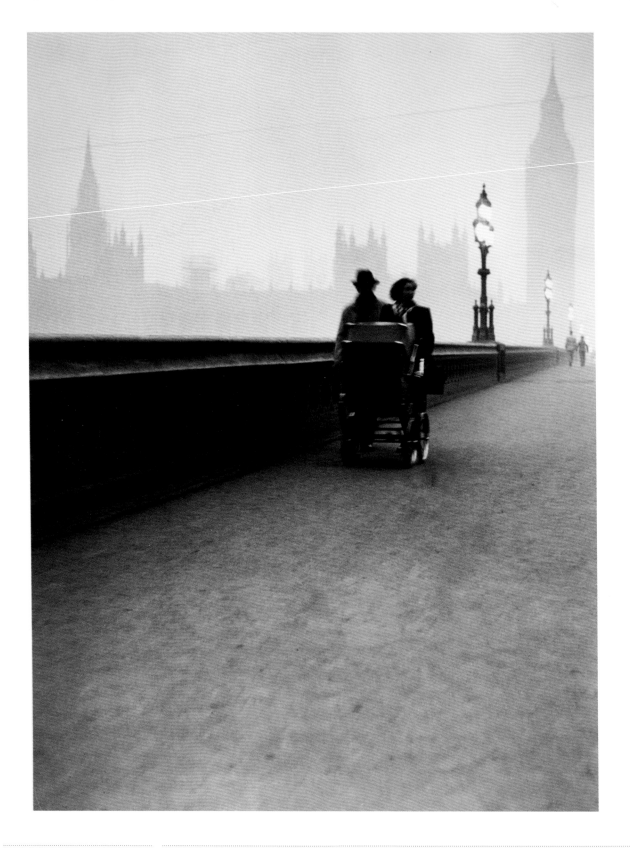

32.
René Groebli

London 1949, later print
Photograph, gelatin silver print on paper 34.5 x 24.8

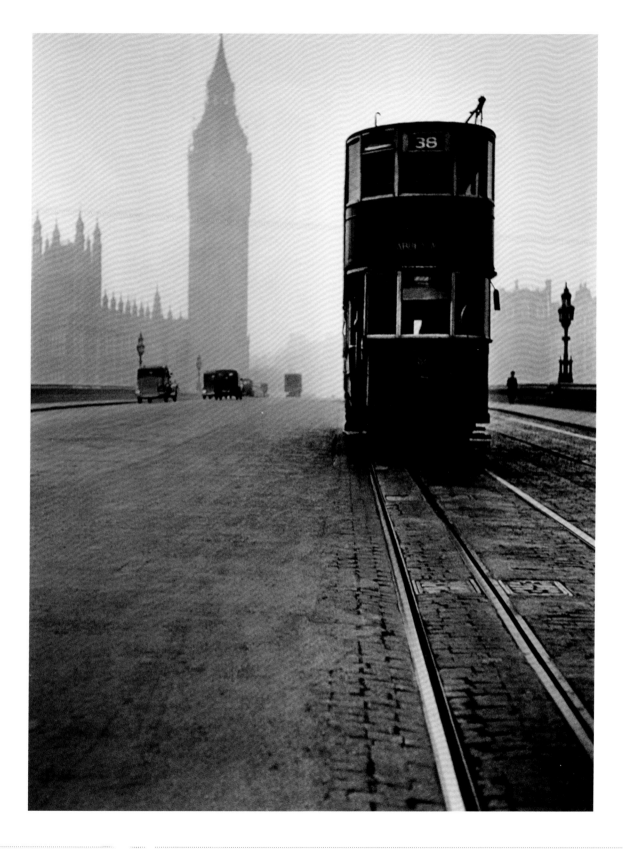

33.
René Groebli

Tram on Westminster Bridge 1949, later print
Photograph, gelatin silver print on paper 34.6 x 25.9

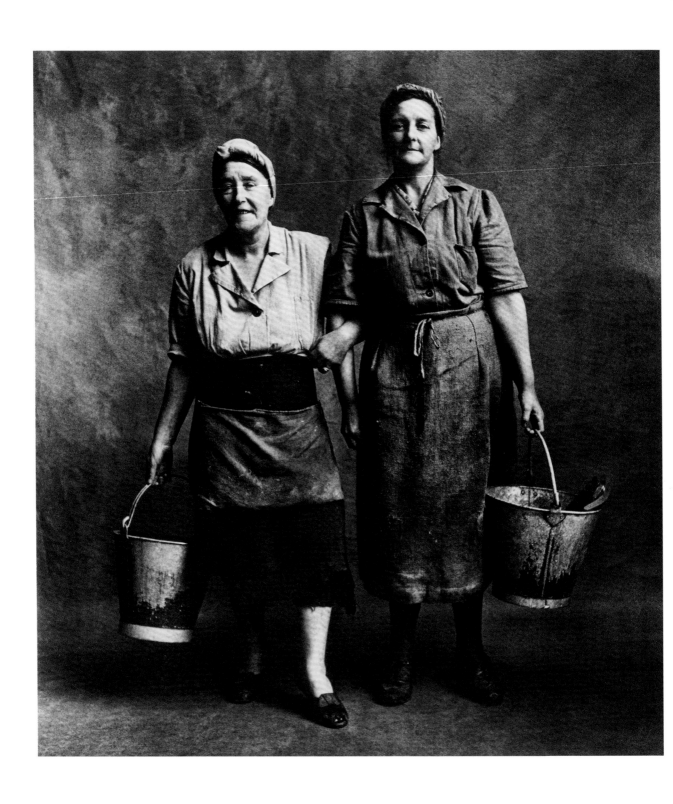

34.
Irving Penn

Cleaning Women, London 1950, printed 1976
Photograph, platinum-palladium print on paper 61.1 x 50.9

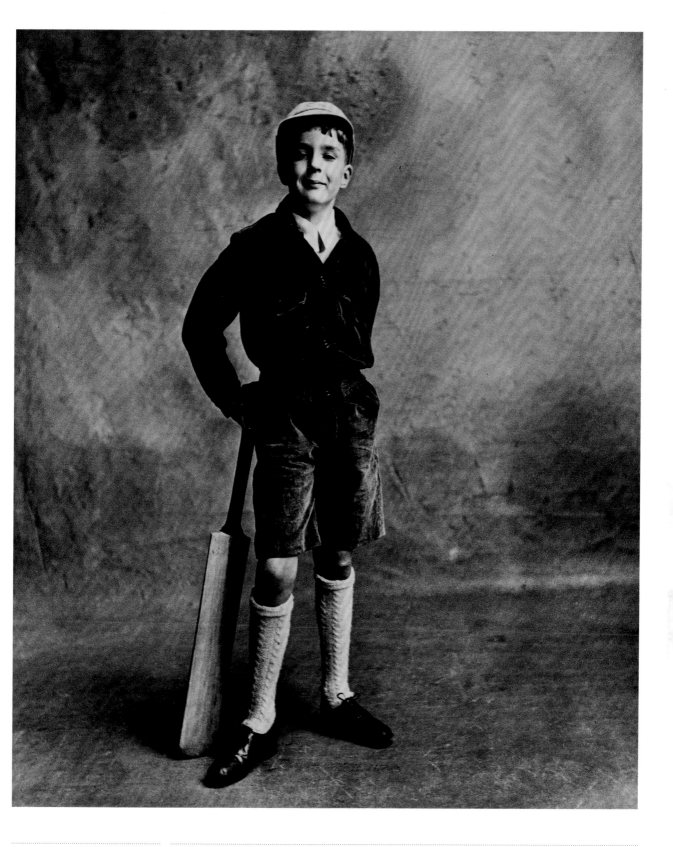

35.
Irving Penn

Young Cricketer (Adam Roundtree), London 1950, later print
Photograph, gelatin silver print on paper 41 x 34.5

36.
Wolfgang Suschitzky

Hampstead Heath Fair 1949, later print
Photograph, gelatin silver print on paper 32.8 x 28.8

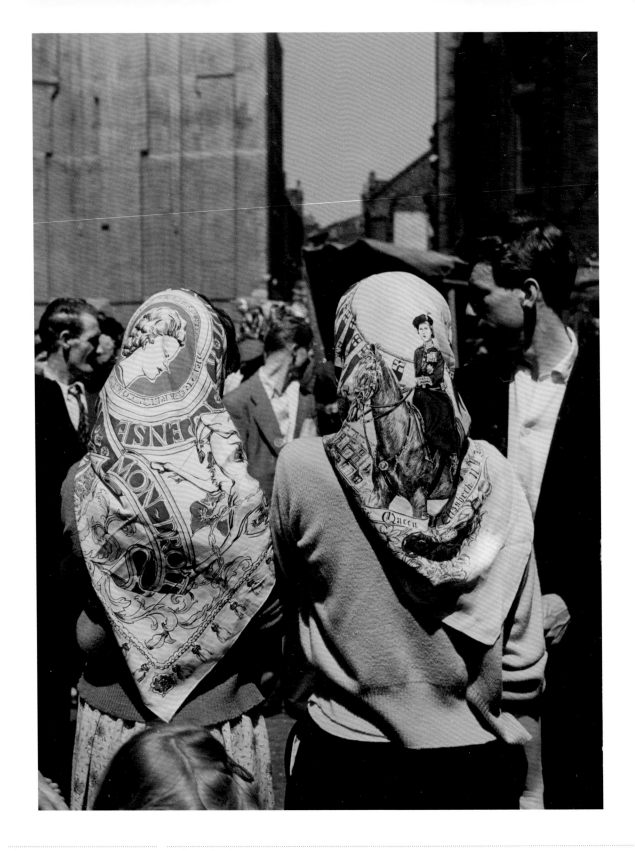

38.
Izis Bidermanas

London [undated]]
Photograph, gelatin silver print on paper 25.8 x 18.8

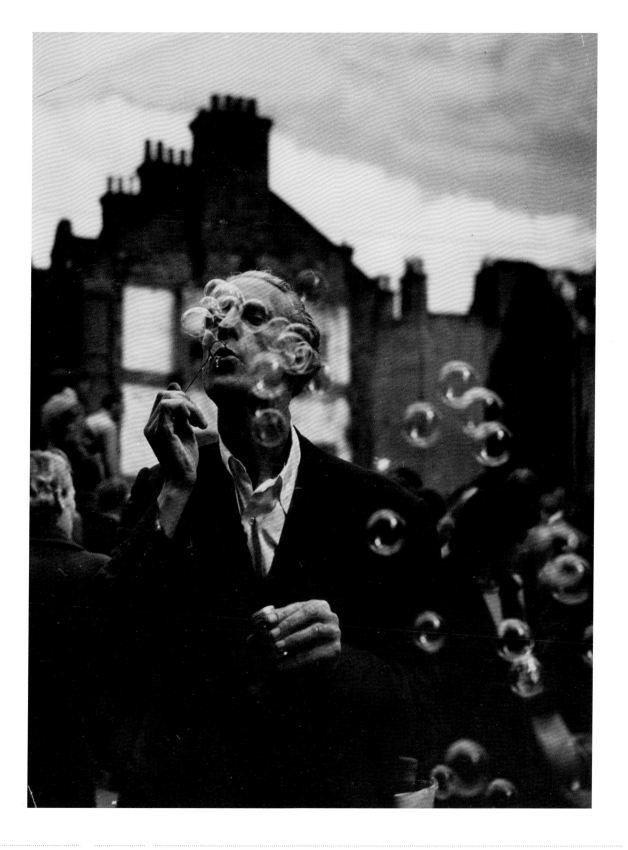

39.
Izis Bidermanas

Man blowing bubbles, Whitechapel, London 1950
Photograph, gelatin silver print on paper 28.6 x 21.9

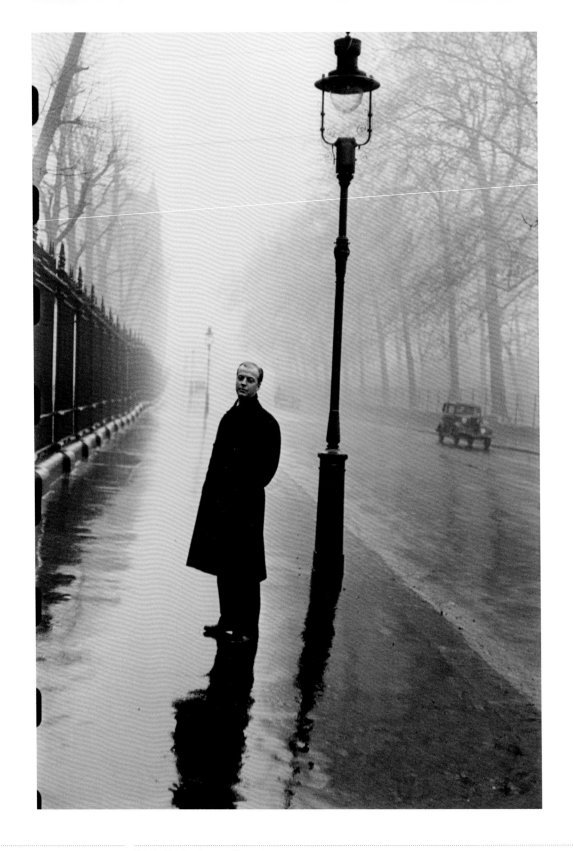

40.
Elliot Erwitt

Eric Ambler, London 1952, later print
Photograph, gelatin silver print on paper 46 x 30.9

41.
Robert Frank

London 1951
Photograph, gelatin silver print on paper 16.2 x 24.6

42.
Elliot Erwitt

Bus Stop, London 1952, later print
Photograph, gelatin silver print on paper 45.6 x 30.7

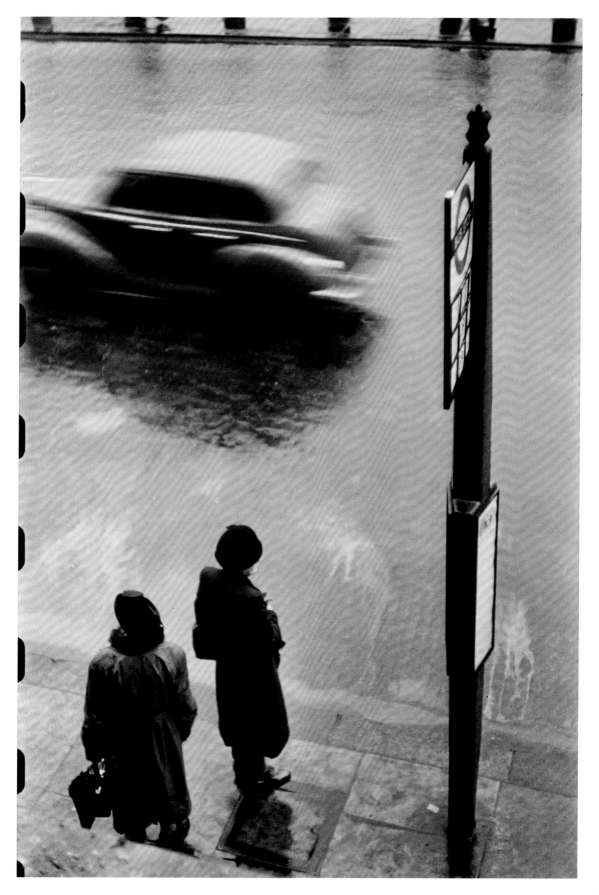

43.
Henri Cartier-Bresson

The embankment in morning, looking east from the roof of Temple underground station,
Workers going to offices 1951
Photograph, gelatin silver print on paper 24 x 35.1

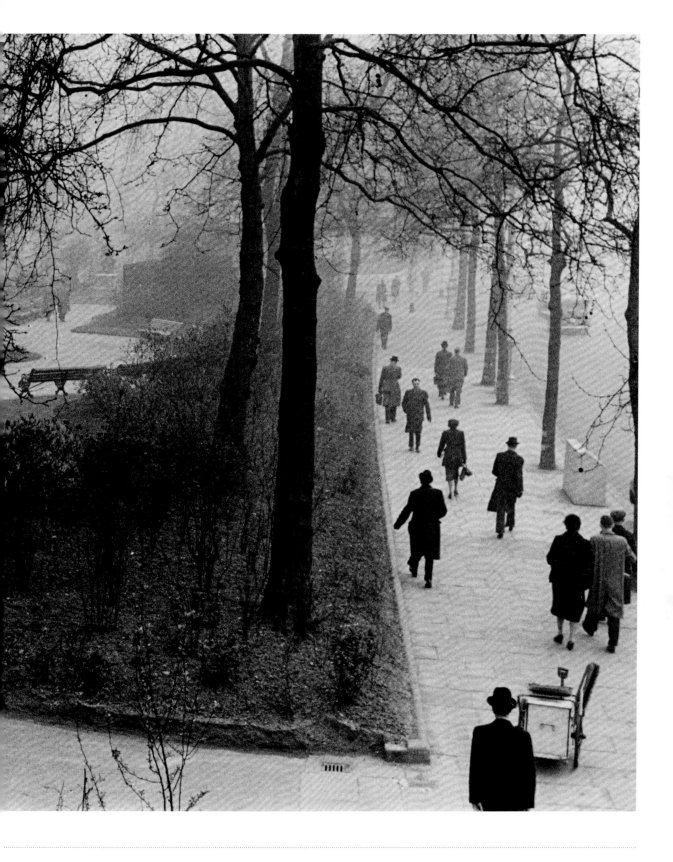

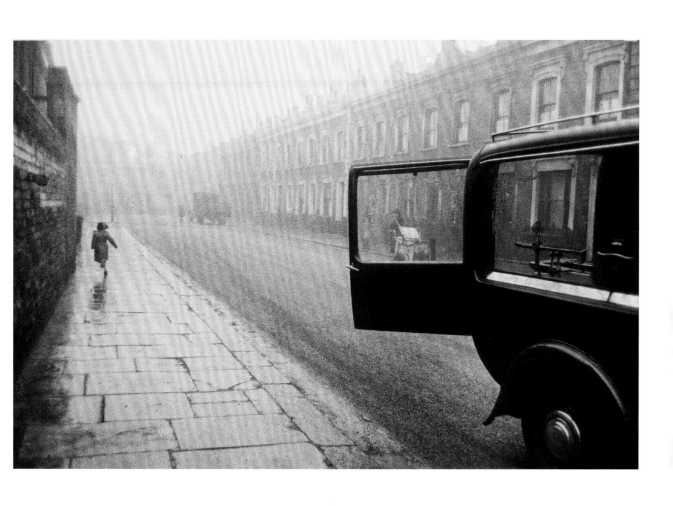

44.
Robert Frank

London 1951, printed 1970s
Photograph, gelatin silver print on paper 22.1 x 34.2

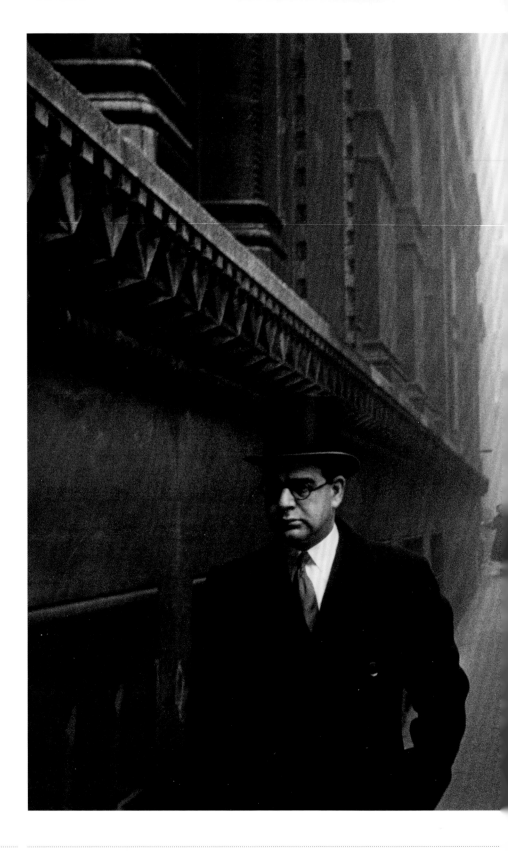

45.
Robert Frank

City of London 1951, printed 1970s
Photograph, gelatin silver print on paper 23.3 x 34.5

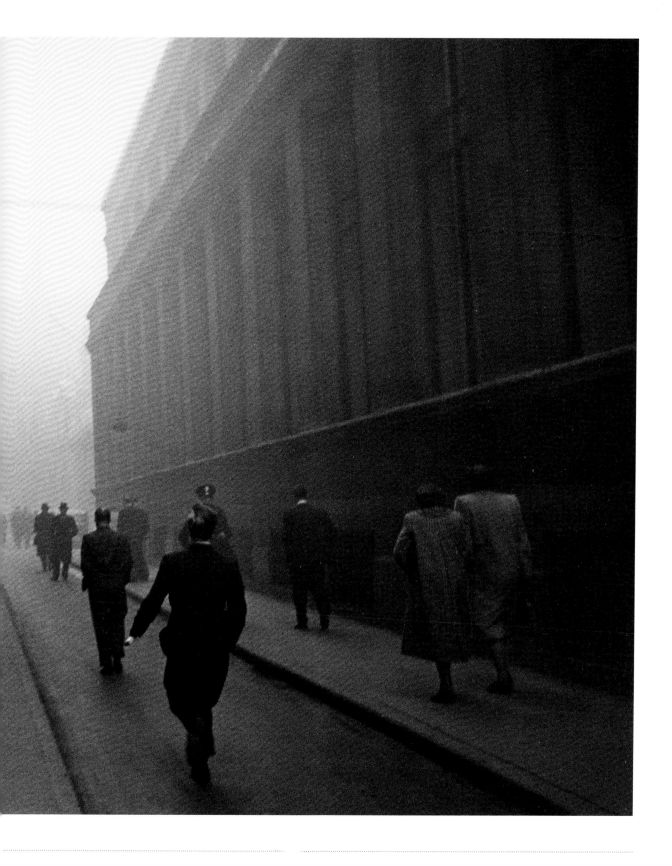

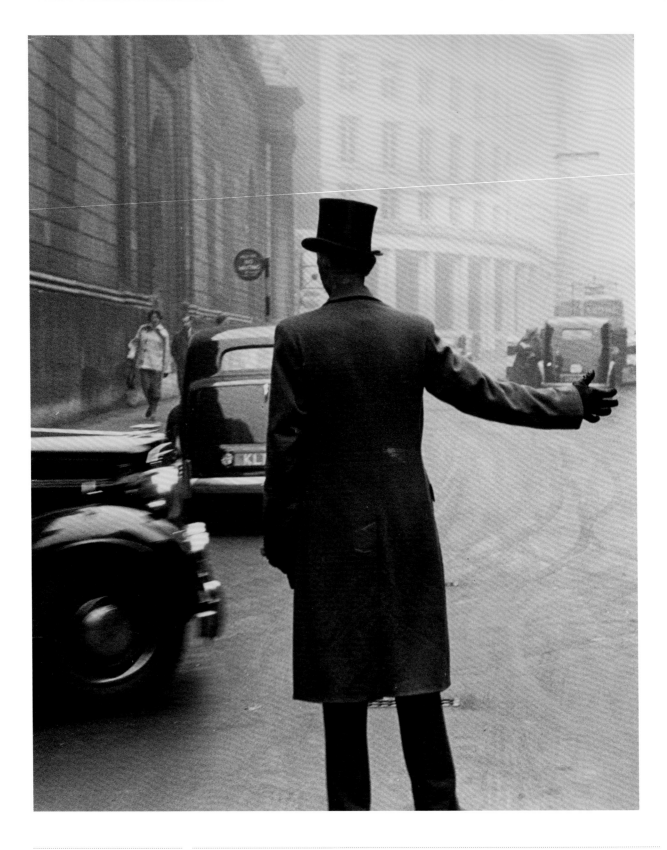

46
Robert Frank

London c.1951-2, printed 1990s
Photograph, gelatin silver print on paper 31.4 x 25.5

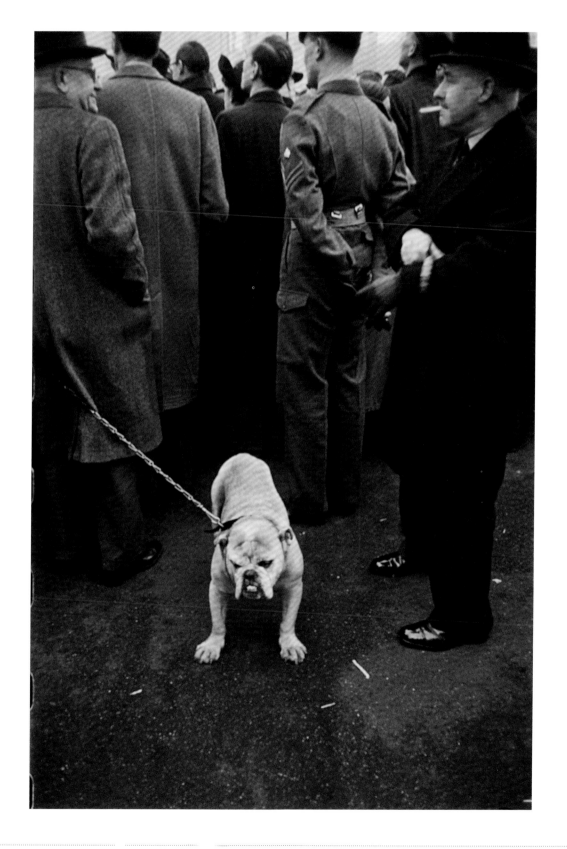

47.
Robert Frank

Hyde Park, London c.1951–2, printed 1990s
Photograph, gelatin silver print on paper 33.2 x 22.2

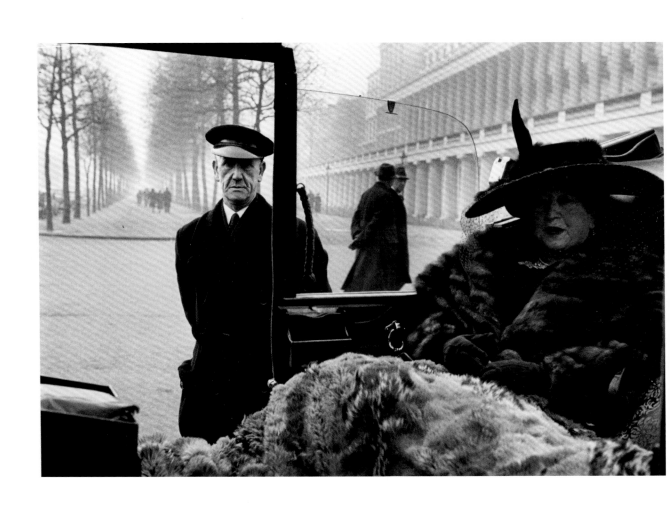

48.
Inge Morath

Mrs Eveleigh Nash, The Mall, London 1953, later print
Photograph, gelatin silver print on paper 22.6 x 33.4

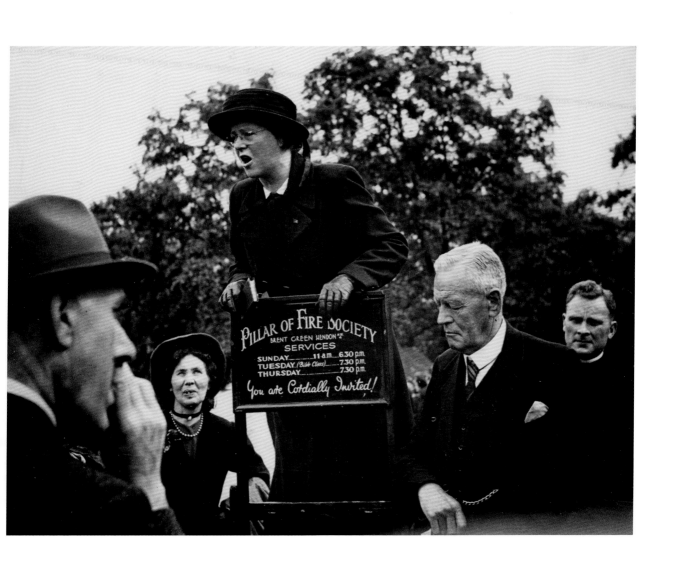

49.
Ernst Haas

Hyde Park, London 1953
Photograph, gelatin silver print on paper 19 x 24.9

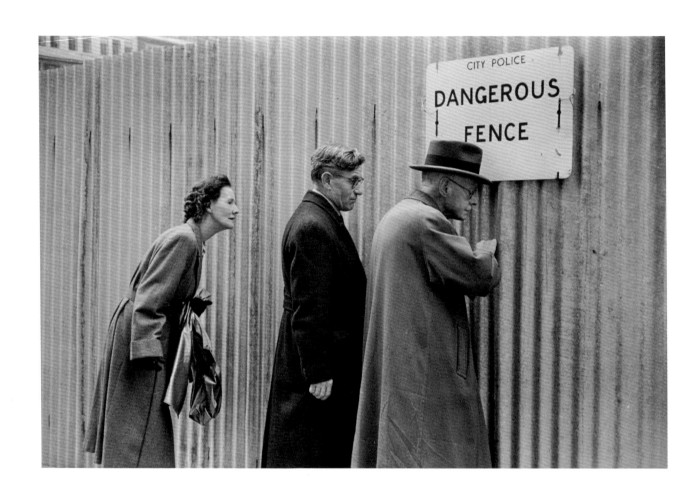

50.
Marc Riboud

London 1954, later print
Photograph, gelatin silver print on paper 30.2 x 45.7

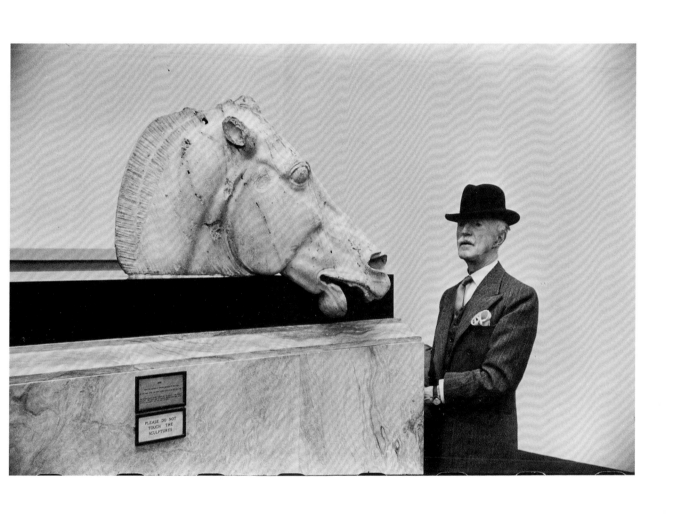

51.
Marc Riboud

The British Museum 1954, later print
Photograph, gelatin silver print on paper 21.9 x 32.5

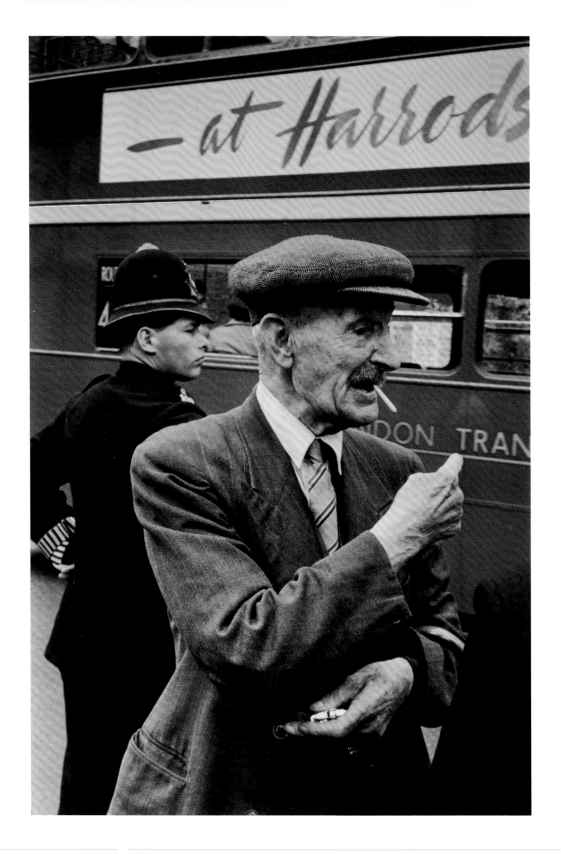

52.
Marc Riboud

London 1955, later print
Photograph, gelatin silver print on paper 32.4 x 21.6

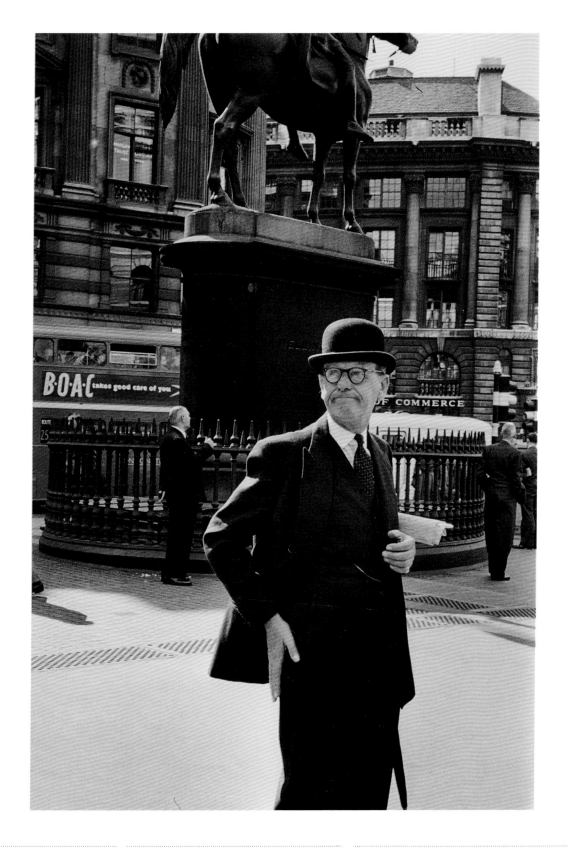

53.
Marc Riboud

London 1955, later print
Photograph, gelatin silver print on paper 32.4 x 21.7

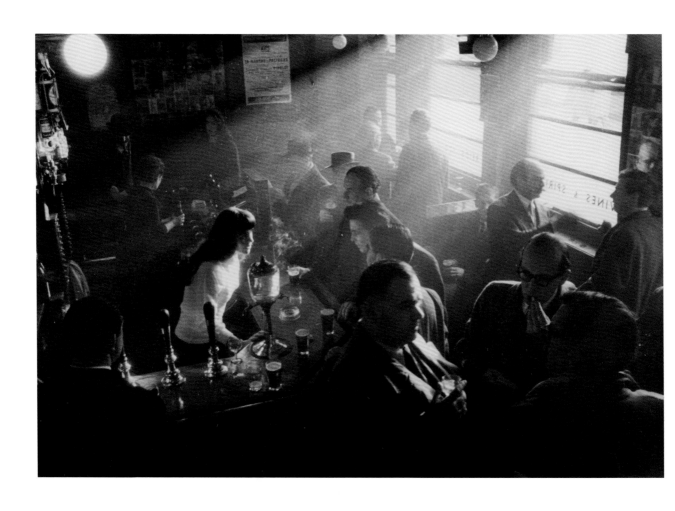

54.
Willy Ronis

Gaston Berlemont's pub, The French House, Soho, London 1955
Photograph, gelatin silver print on paper 27.5 x 39.6

55.
Elliot Erwitt

London 1952, later print
Photograph, gelatin silver print on paper 30.9 x 46.2

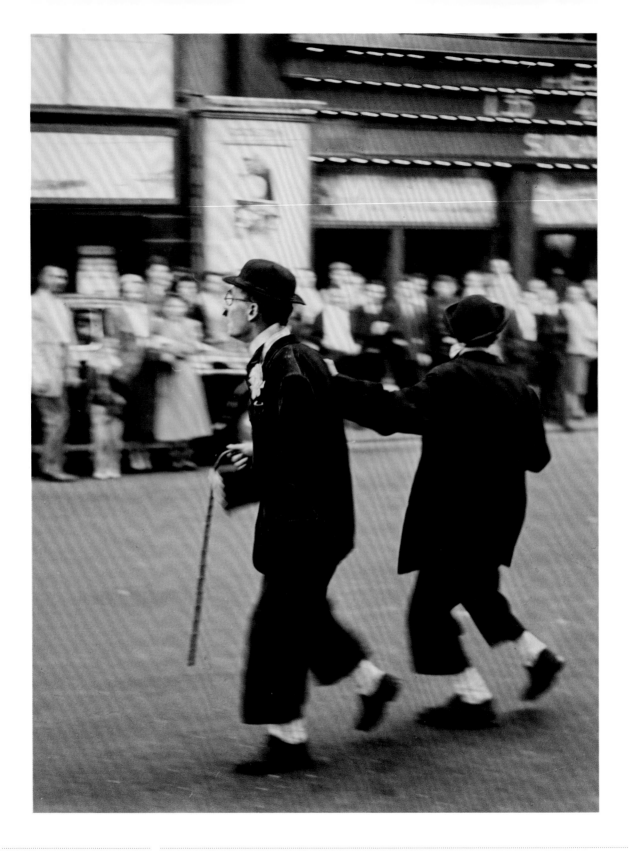

56.
Hannes Kilian

London 1955
Photograph, gelatin silver print on paper 30.5 x 23.7

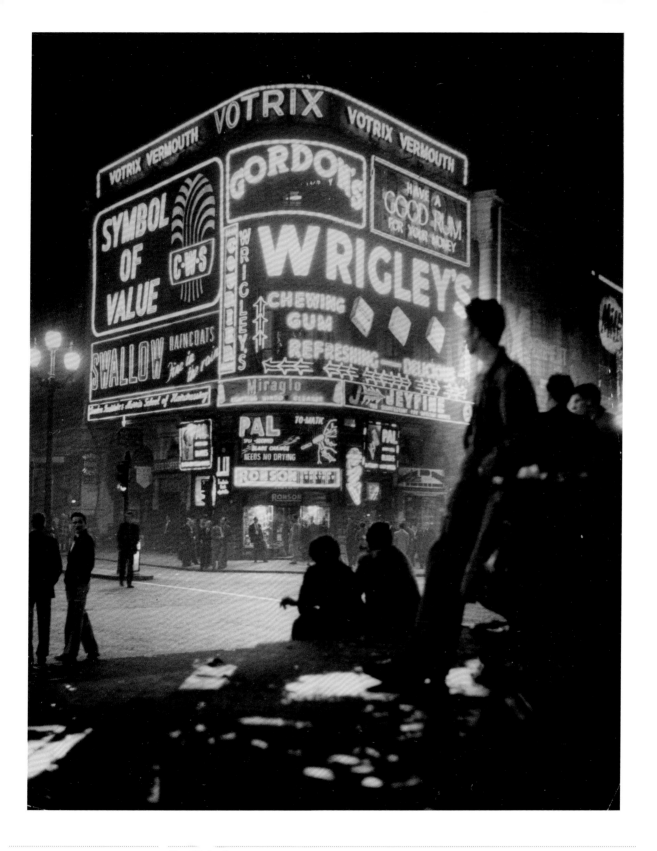

57.
Hannes Kilian

Piccadilly, London 1955
Photograph, gelatin silver print on paper 28.7 x 23.2

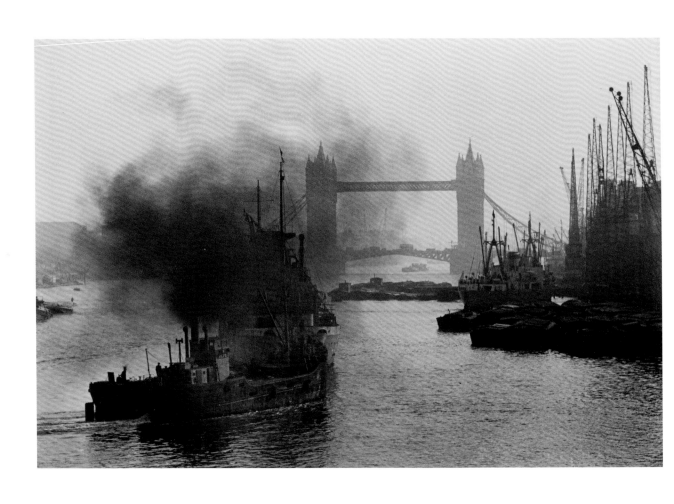

58.
Edouard Boubat

Pool of London 1958
Photograph, gelatin silver print on paper 25 x 37

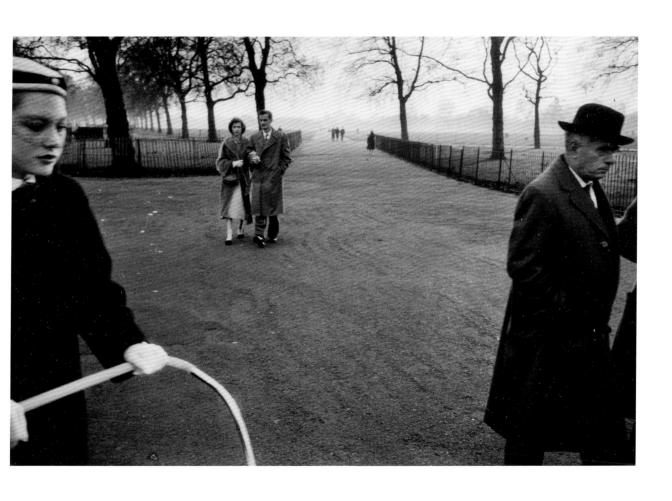

59.
Sergio Larrain

London 1959
Photograph, gelatin silver print on paper 13.2 x 19.9

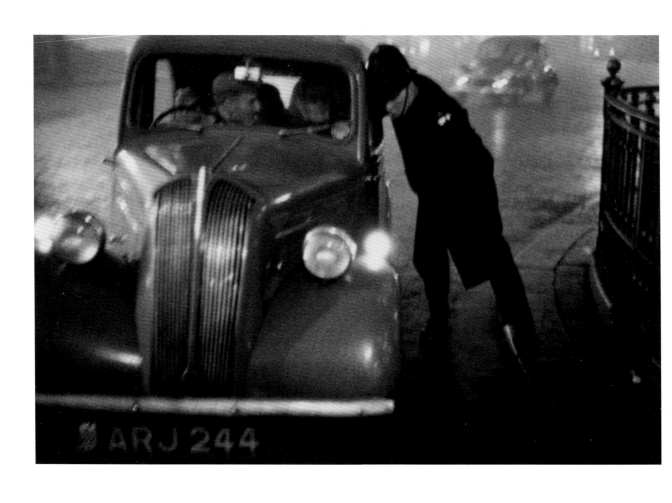

60.
Sergio Larrain

London 1959, later print
Photograph, gelatin silver print on paper 13.4 x 19.9

61.
Sergio Larrain

London 1959, later print
Photograph, gelatin silver print on paper 13.4 x 19.9

62.
Elliot Erwitt

London 1956, later print
Photograph, gelatin silver print on paper 29.8 x 44.9

63
Bruce Davidson

Bombed out car park 1960, later print
Photograph, gelatin silver print on paper 32.3 x 47.9
Signed in pencil on the verso

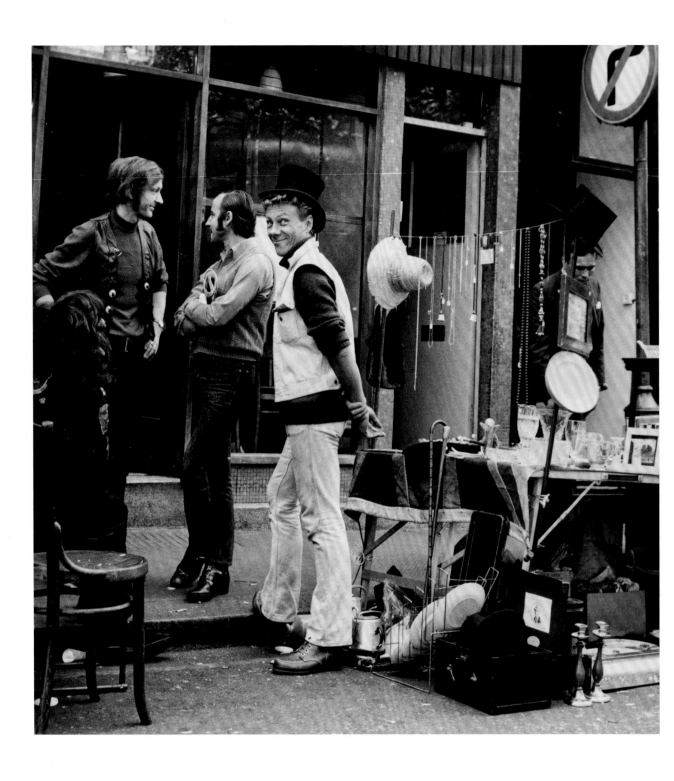

64.
Dorothy Bohm

Earlham Street, **Covent Garden, London** 1960s
Photograph, gelatin silver print on paper 32.5 x 30

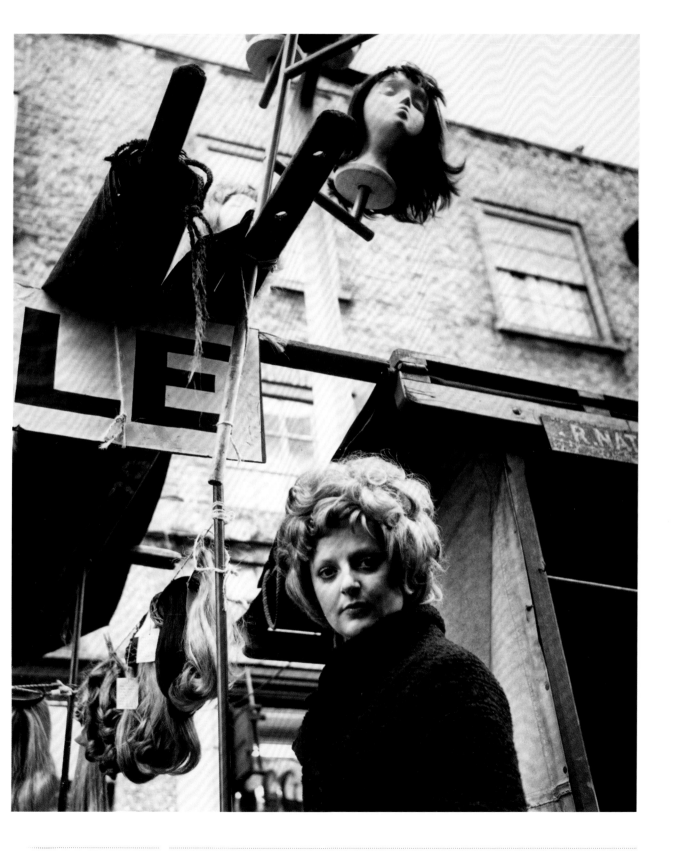

65.
Dorothy Bohm

Petticoat Lane Market, East End, London 1960s
Photograph, gelatin silver print on paper 35.4 x 29

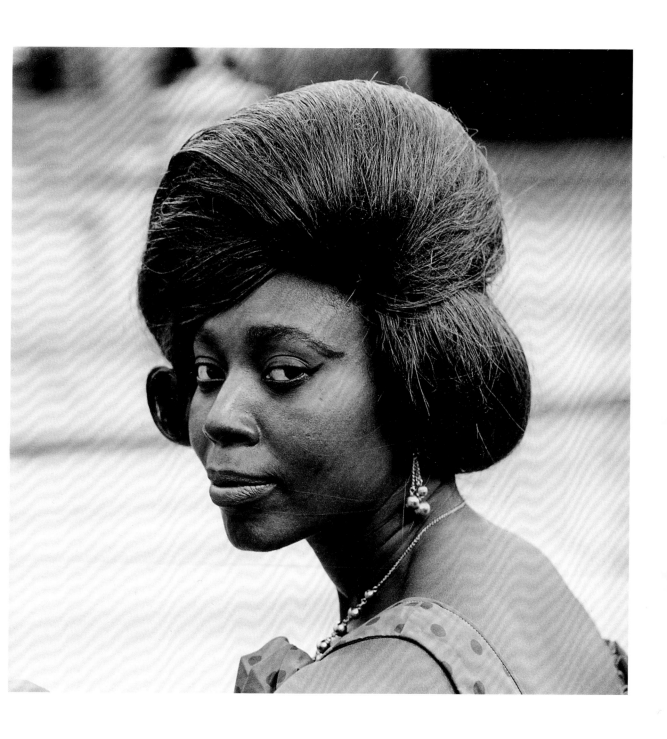

66.
James Barnor

Eva, London c.1965, printed 2010
Photograph, gelatin silver print on paper 28.2 x 28.4

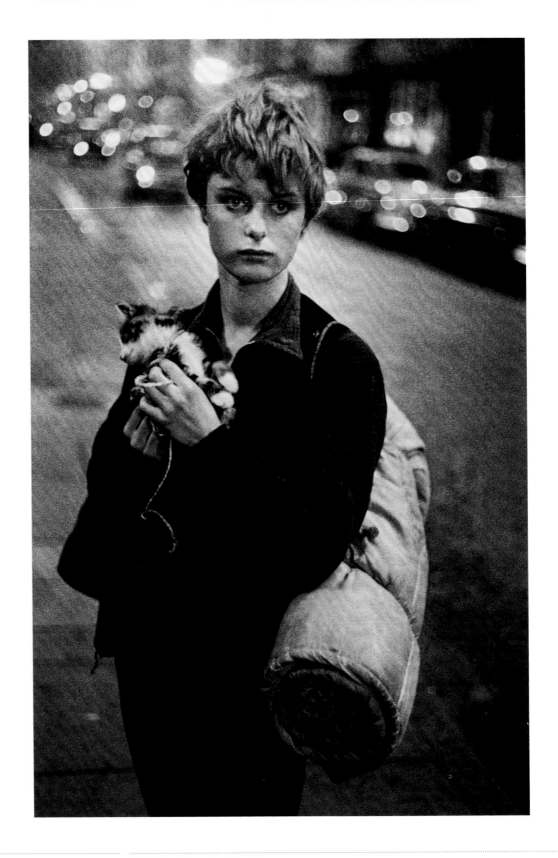

67.
Bruce Davidson

Girl holding kitten 1960, later print
Photograph, gelatin silver print on paper 46 x 30.8

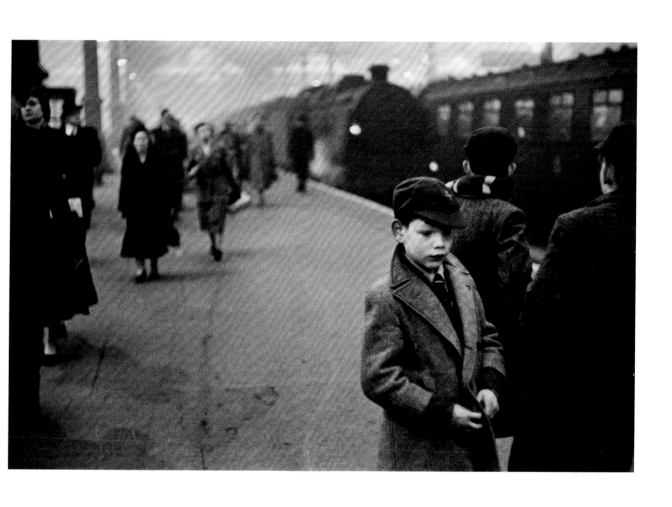

68.
Bruce Davidson

Young boy at Paddington Station, London 1956, later print
Photograph, gelatin silver print on paper 32.3 x 47.9

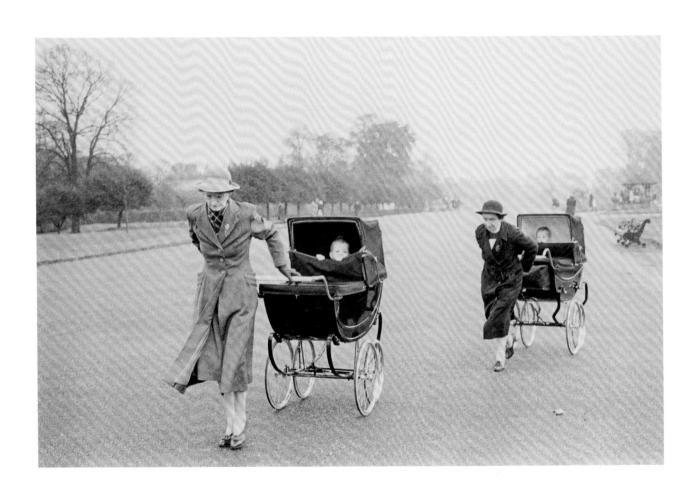

69.
Bruce Davidson

Women with baby carriages 1960, later print
Photograph, gelatin silver print on paper 31.2 x 48

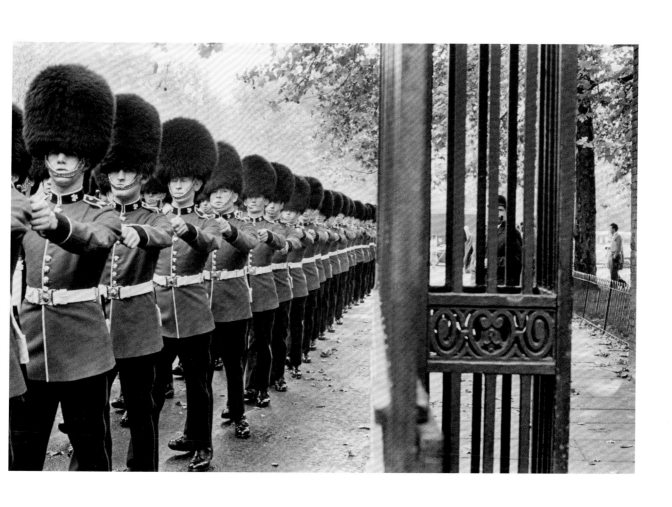

70.
Bruce Davidson

Queen's guard marching 1960, later print
Photograph, gelatin silver print on paper 32.3 x 48

71.
Eve Arnold

One of four girls who share a flat in Knightsbridge 1961
Photograph, gelatin silver print on paper 24.6 x 16.5

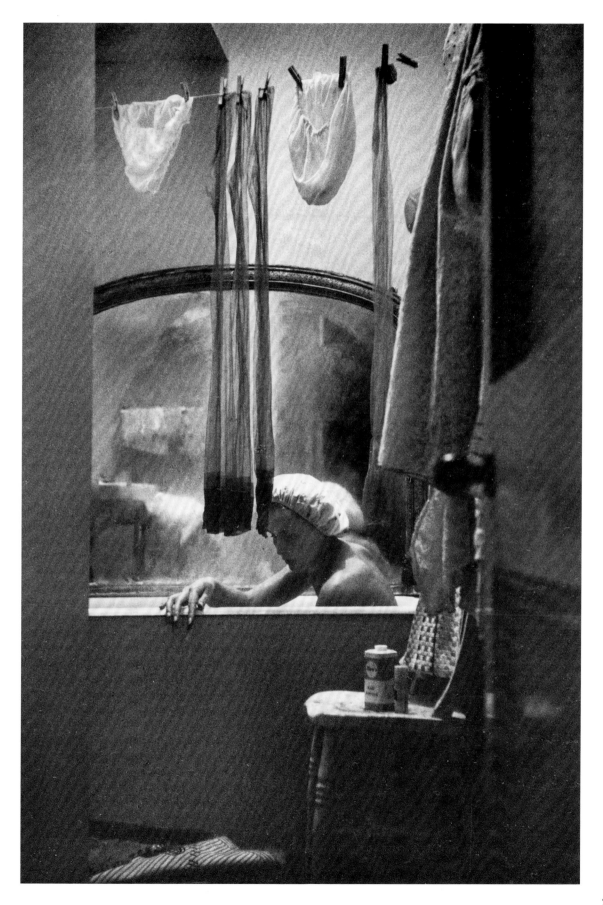

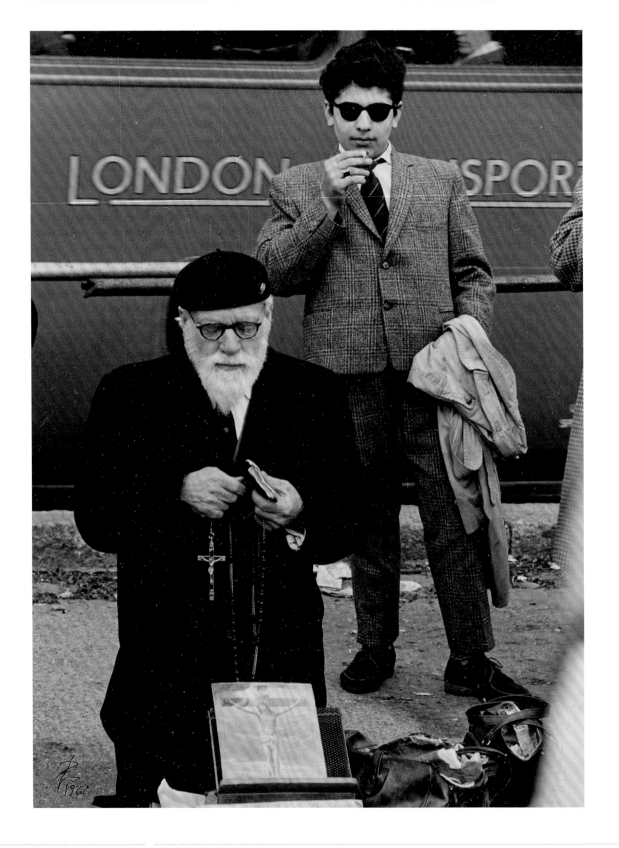

72.
Lutz Dille

Untitled 1961
Photograph, gelatin silver print on paper 23.9 x 17.6

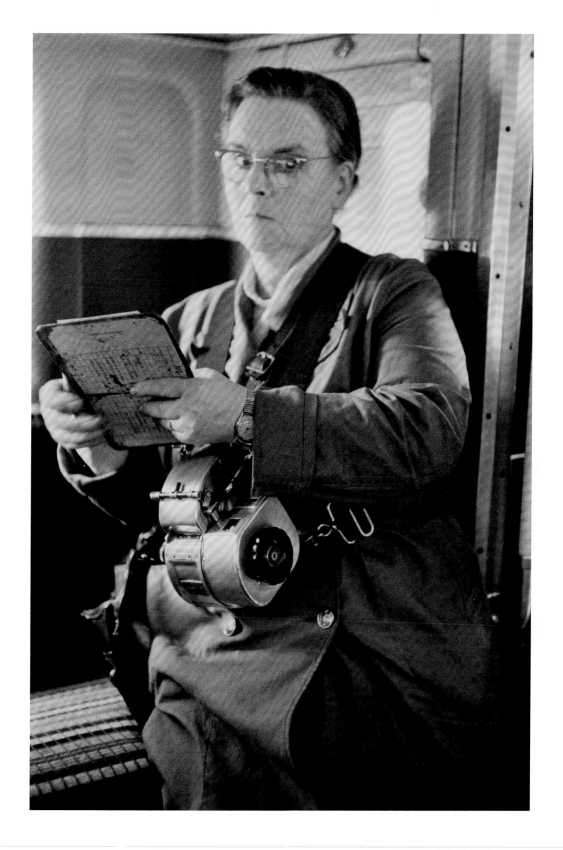

Bus conductor woman with ticket machine 1960, later print
Photograph, gelatin silver print on paper 48.1 x 32.4

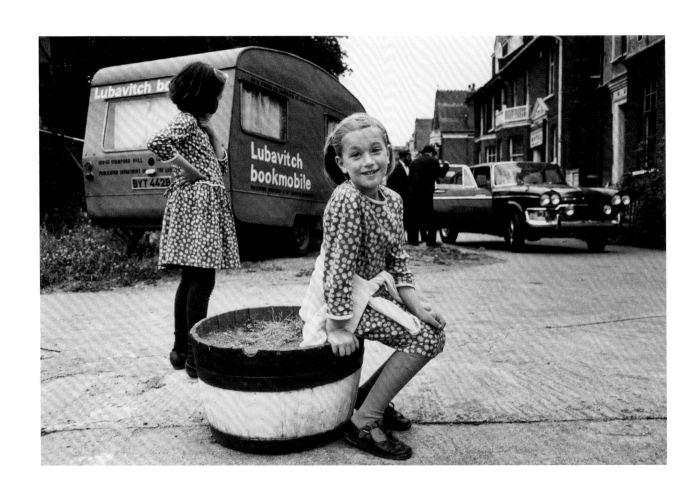

74.
Leonard Freed

Girls outside the Lubavitch Hassidic Jewish community school, London 1971
Photograph, gelatin silver print on paper 20.3 x 30.8

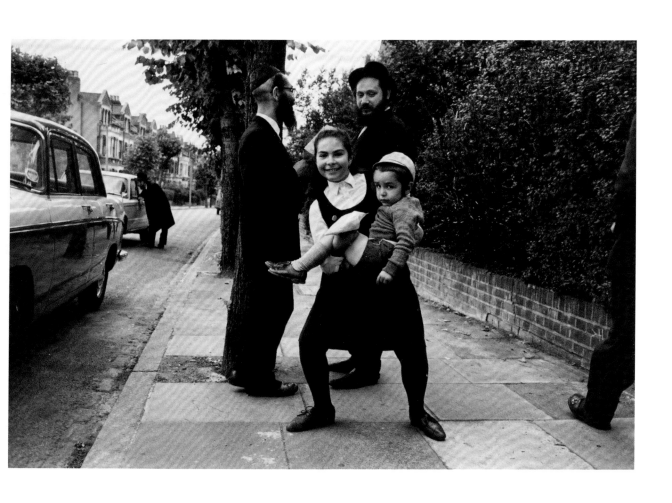

75.
Leonard Freed

Jewish street scene, London 1971
Photograph, gelatin silver print on paper 22.2 x 32.9

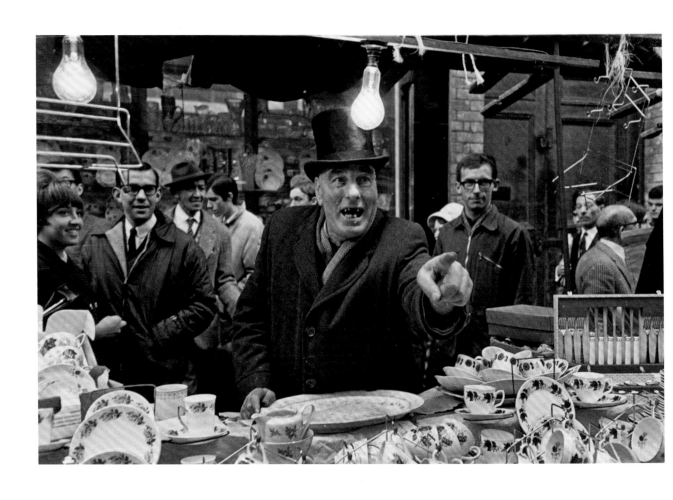

76.
Milon Novotny

Middlesex Market, London 1966
Photograph, gelatin silver print on paper 25.7 x 39.5

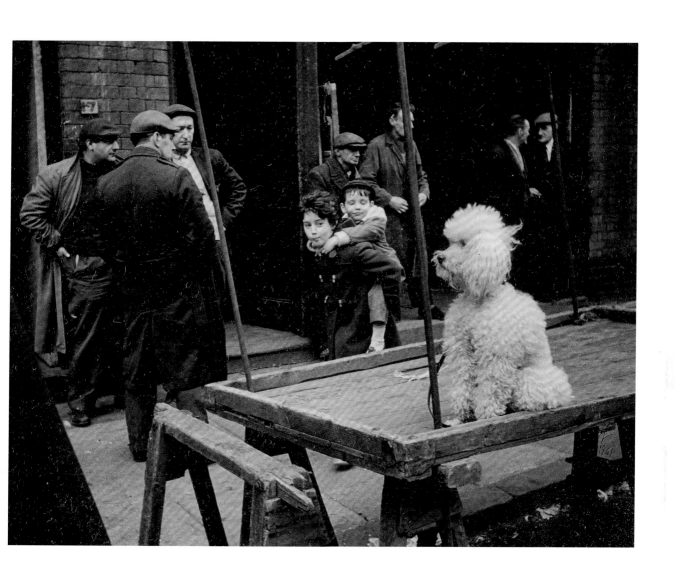

Untitled 1961
Photograph, gelatin silver print on paper 19.1 x 24.3

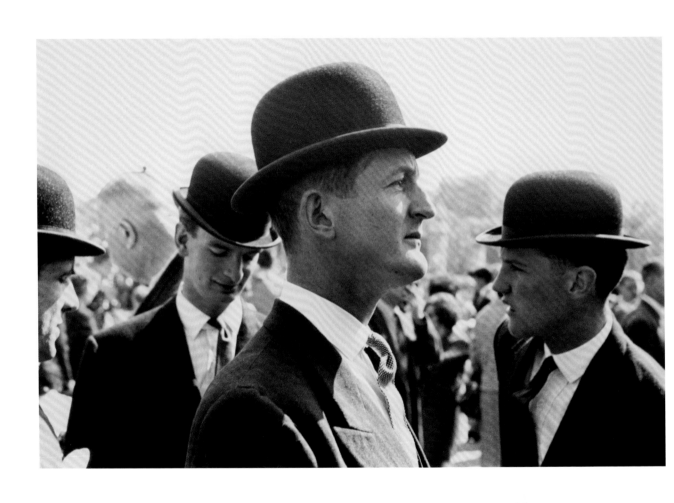

78.
Milon Novotny

Buckingham Palace, London 1966
Photograph, gelatin silver print on paper 25.5 x 37.6

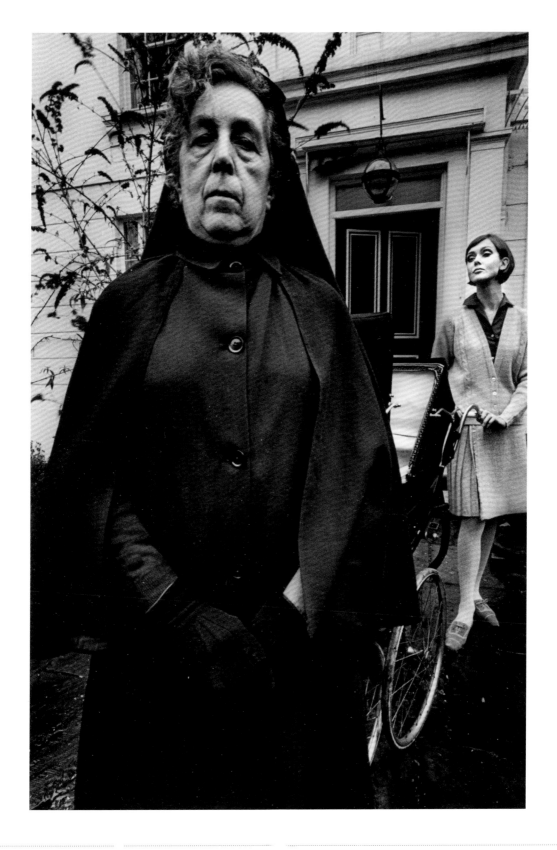

79.
Jeanloup Sieff

English Nanny, England 1965, later print
Photograph, gelatin silver print on paper 30.5 x 19.9

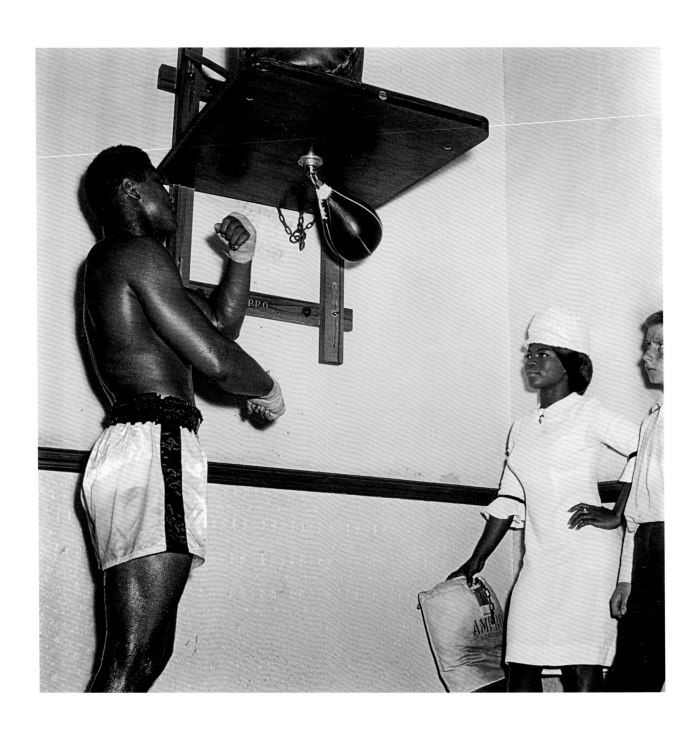

80.
James Barnor

Muhammad Ali training, Earl's Court, London 1966, printed 2010
Photograph, gelatin silver print on paper 28 x 28.3

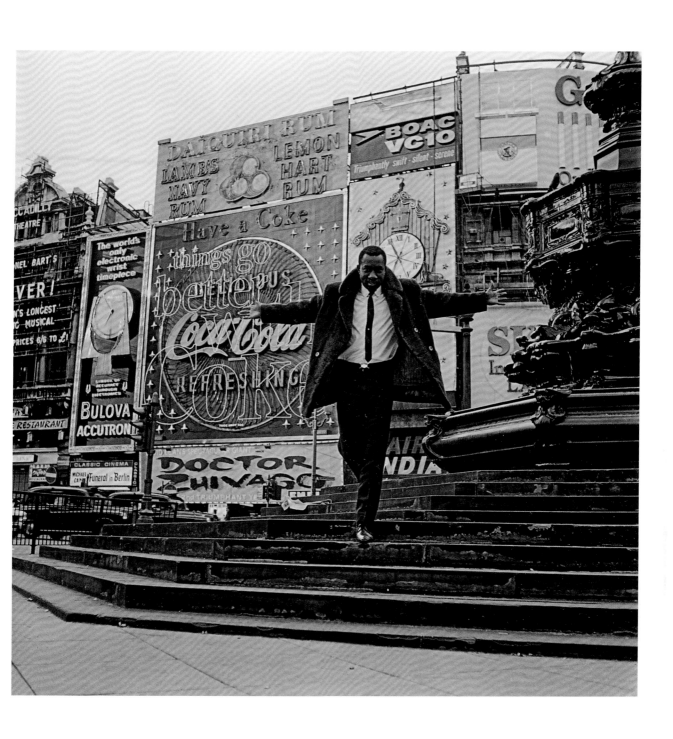

81.
James Barnor

Mike Eghan at Piccadilly Circus, London c.1967, printed 2010
Photograph, gelatin silver print on paper 28.1 x 28.3

82.
Milon Novotny

East End 1966
Photograph, gelatin silver print on paper 24.9 x 37.2

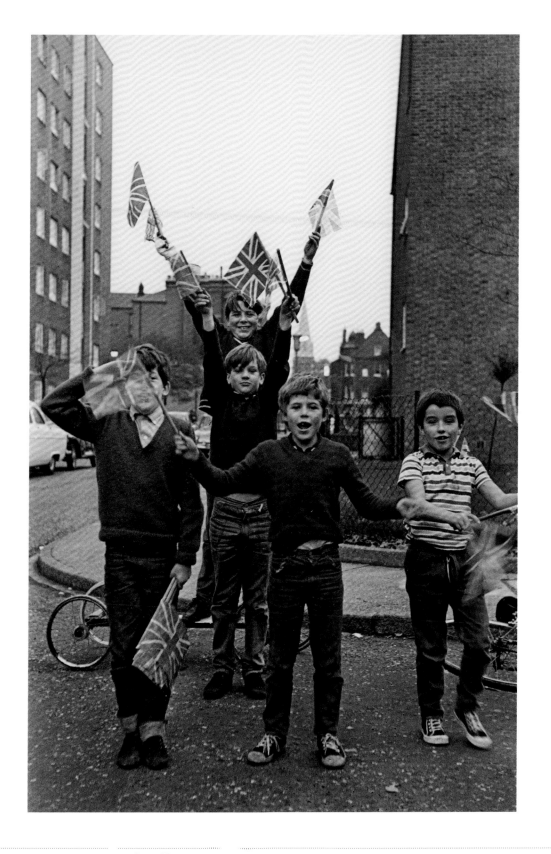

83.
Milon Novotny

London 1966
Photograph, gelatin silver print on paper 37.2 x 24.2

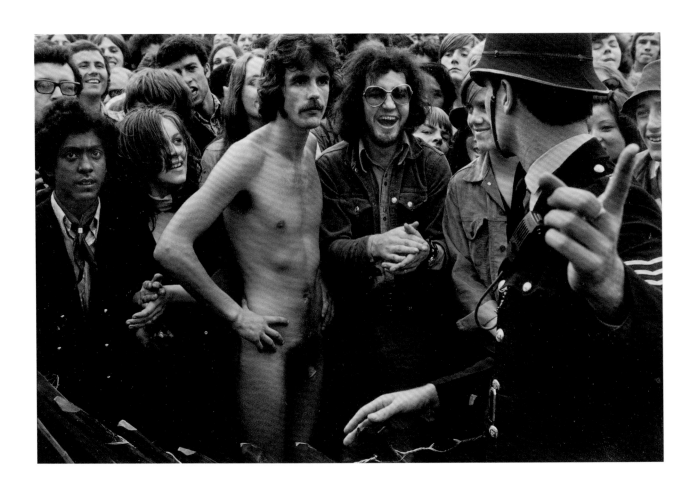

84.
Leonard Freed

Naked man and policeman, London 1971
Photograph, gelatin silver print on paper 22.3 x 33.2

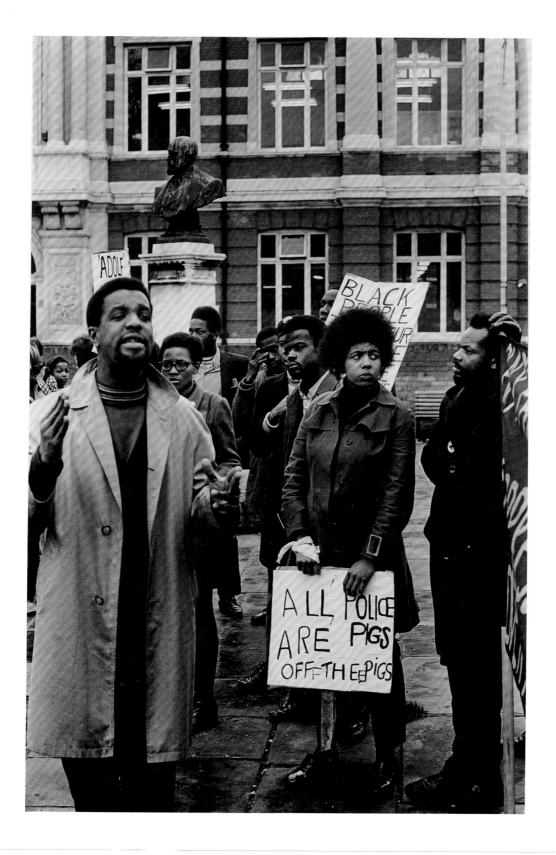

85.
Neil Kenlock

Demonstration outside Brixton Library 1972, printed 2010
Photograph, gelatin silver print on paper 38.3 x 25.3

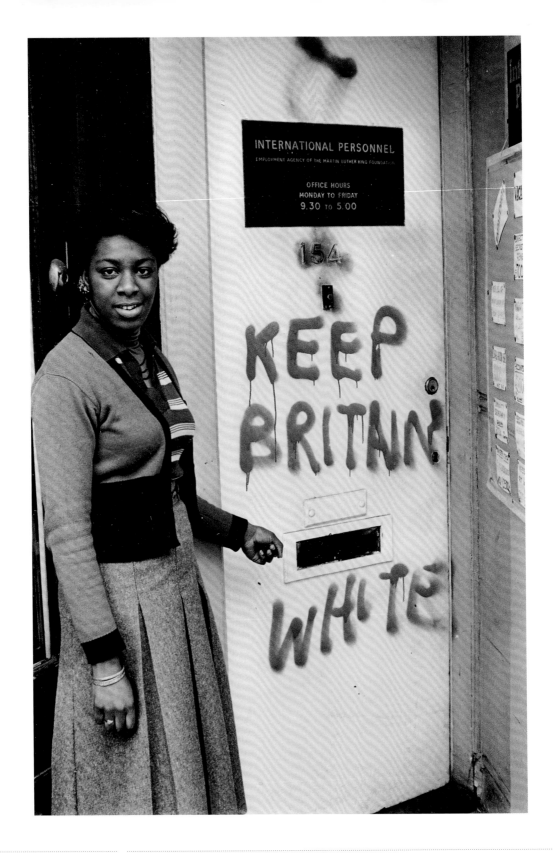

86.
Neil Kenlock

'Keep Britain white' graffiti, Balham 1972, printed 2010
Photograph, gelatin silver print on paper 38.4 x 25.3

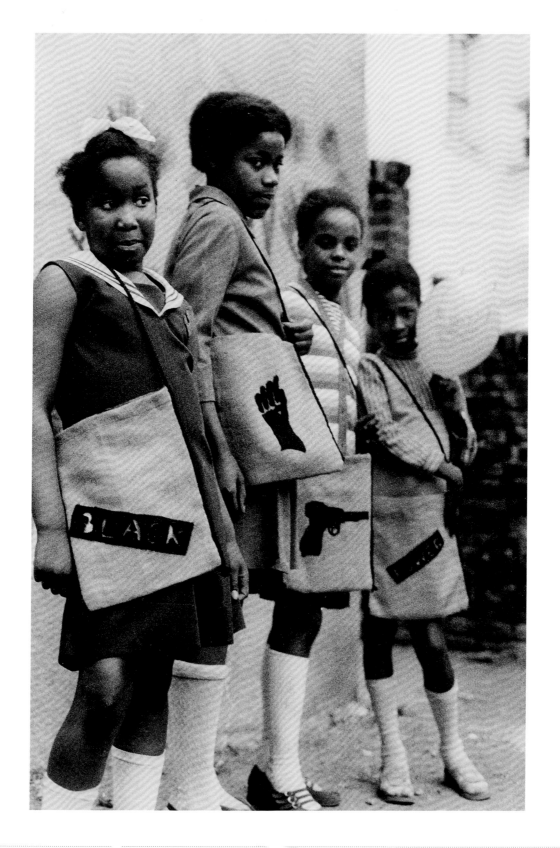

87.
Neil Kenlock

Black Panther school bags 1970, printed 2010
Photograph, gelatin silver print on paper 38.4 x 25.3

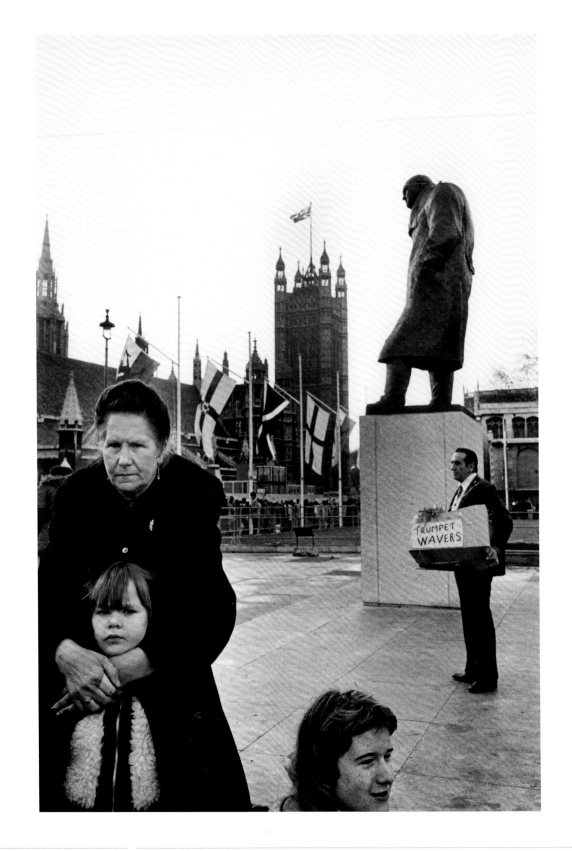

88.
Martine Franck

Princess Anne's Wedding, Parliament Square 1973, later print
Photograph, gelatin silver print on paper 36.1 x 24.2

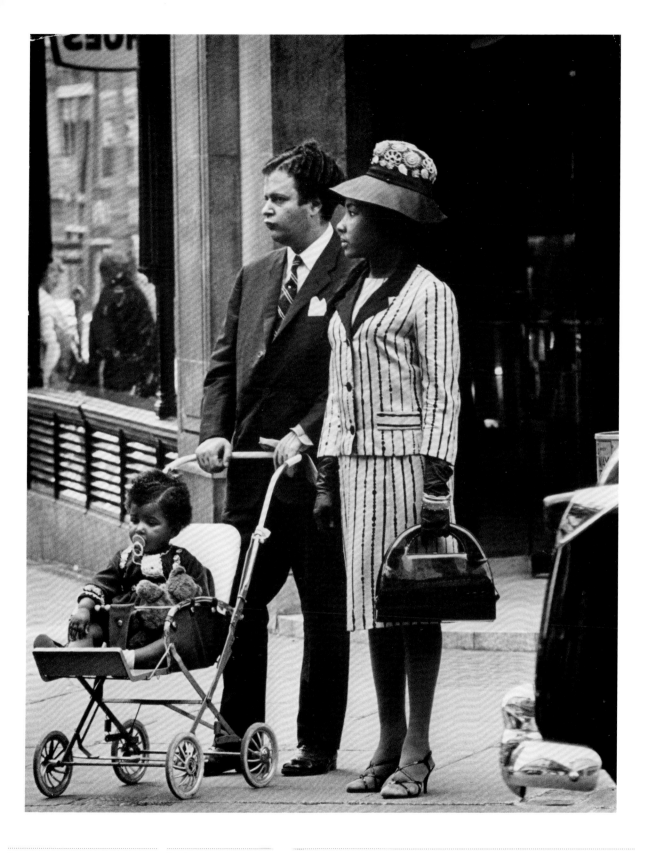

89.
Mario de Biasi

London 1975
Photograph, gelatin silver print on paper 30.5 x 23.8

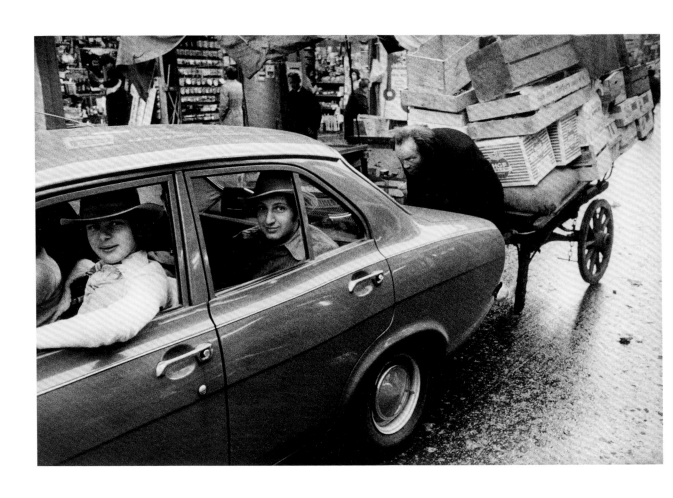

90.
Markéta Luskačová

Petticoat Lane market, London 1977, later print
Photograph, gelatin silver print on paper 28.6 x 43.2

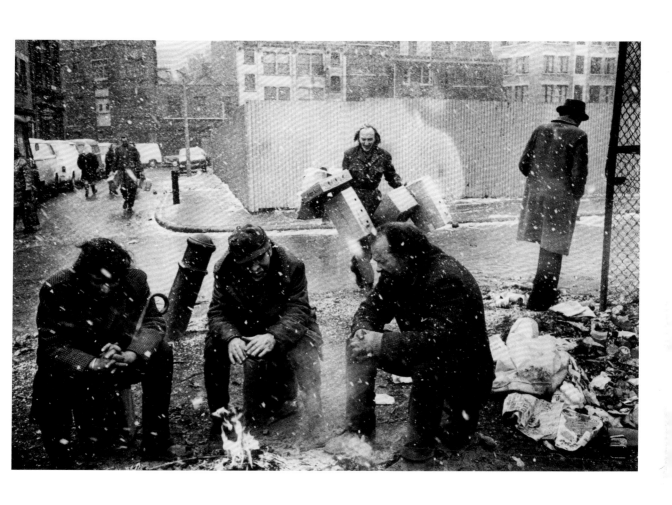

91.
Markéta Luskačová

People around a fire, Spitalfields Market, London 1976, later print
Photograph, gelatin silver print on paper 29.5 x 42.8

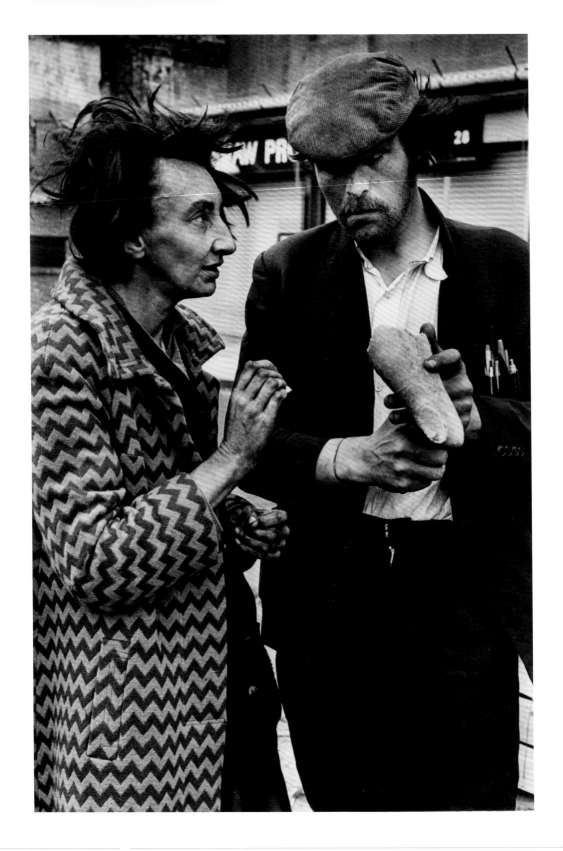

92.
Markéta Luskačová

Woman and man with bread, Spitafields, London 1976, later print
Photograph, gelatin silver print on paper 42.7 x 28.6

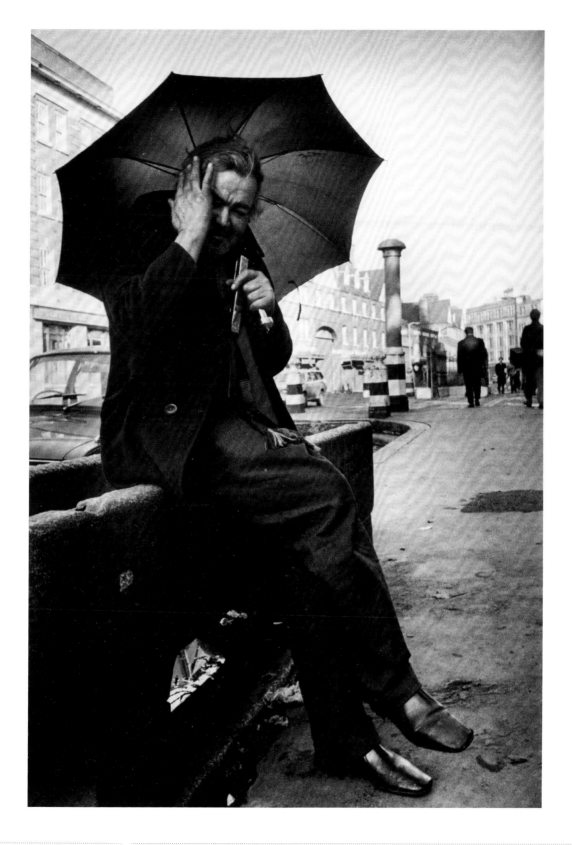

93.
Markéta Luskačová

Man playing mouthorgan in front of Christ Church, Commercial Road, London 1987, later print
Photograph, gelatin silver print on paper 42.7 x 29

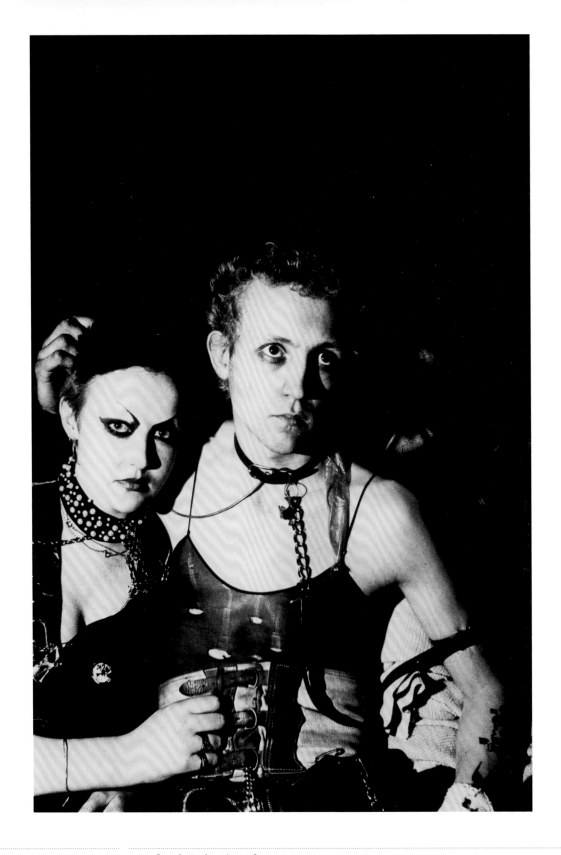

94.
Karen Knorr
Olivier Richon

Roxy 4 from the Punks series 1976
Photograph, gelatin silver print on paper 27.8 x 19.3

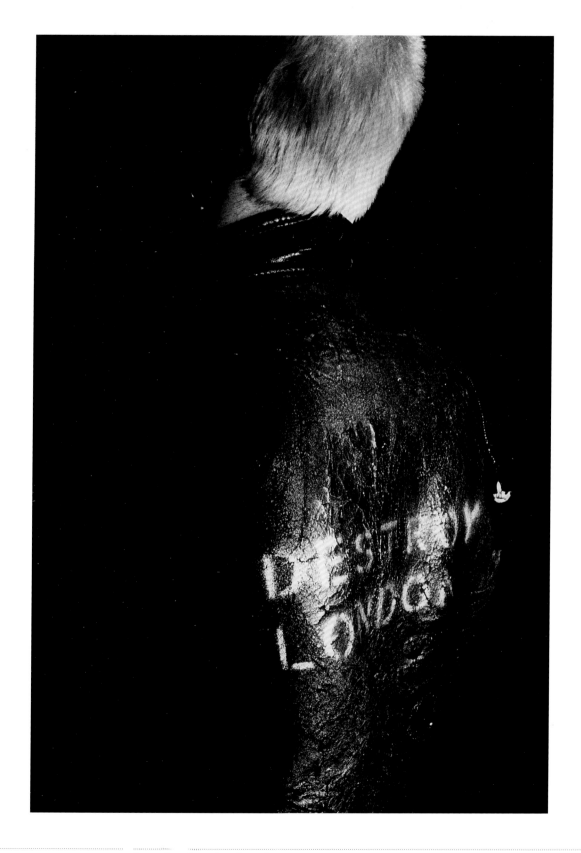

95.
Karen Knorr
Olivier Richon

Destroy from the Punks series 1976
Photograph, gelatin silver print on paper 26 x 17.8

Greenwich, London 1977
Photograph, gelatin silver print on paper
36 x 24.2

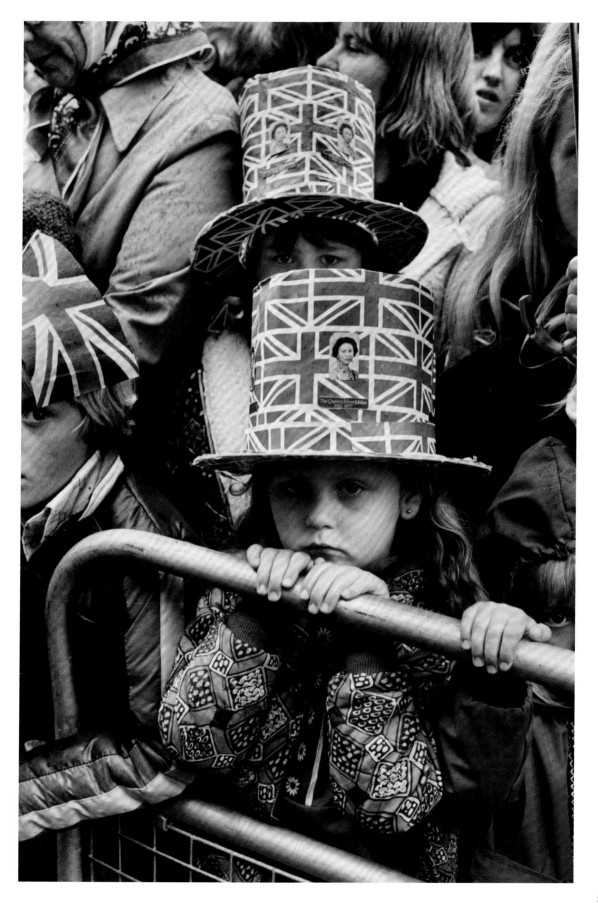

97.
Al Vandenberg

Untitled c.1975–80, from the series *On a Good Day*
Photograph, gelatin silver print on paper
18.9 x 11.7

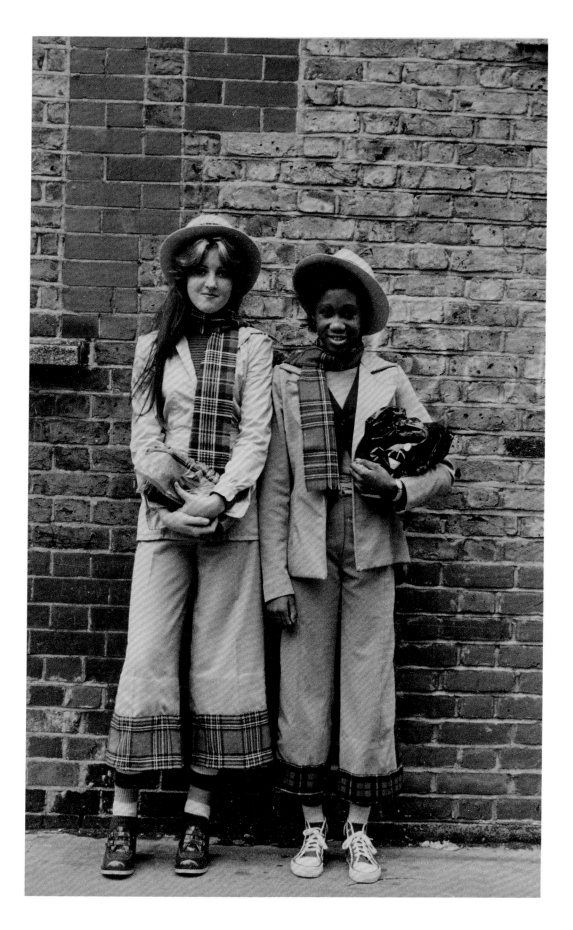

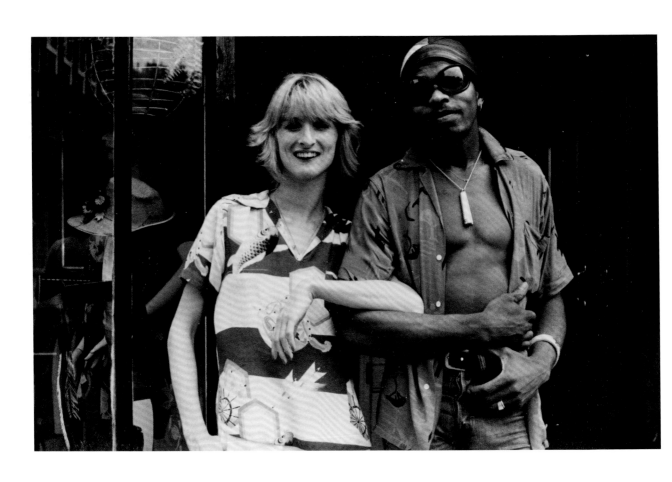

98.
Al Vandenberg

Untitled c.1975–80, from the series *On a Good Day*
Photograph, gelatin silver print on paper 9 x 14

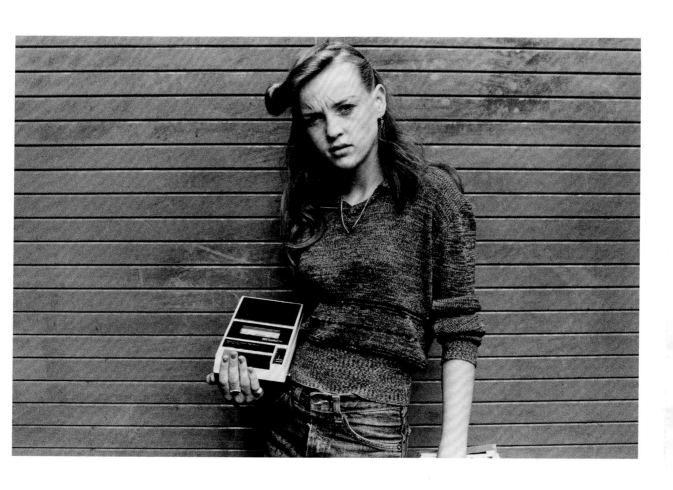

99.
Al Vandenberg

Untitled 1975, from the series *On a Good Day*
Photograph, gelatin silver print on paper 12 x 18.5

Hyde Park, London 1978, later print
Photograph, gelatin silver print on paper 45.6 x 30.3

Curators' Acknowledgements

Another London is entirely made up of photographs taken from a remarkable donation to Tate: the Eric and Louise Franck London Collection. In developing and preparing the exhibition we are enormously indebted to Eric and Louise Franck for providing such generous assistance on so many aspects of the project. Thanks are also due to Augusta Edwards, Saron Hughes and Nicola Mitchell at Eric Franck Fine Art who have all been extraordinarily helpful.

Alice Chasey has ably overseen the publication of the exhibition catalogue and we are also grateful to her Tate Publishing colleagues Roanne Marner, Miriam Perez and Deborah Metherell. The catalogue has been sensitively designed by Glenn Howard at Untitled; we would also like to thank Melissa Larner for her skilful editing, as well as Tate Photography, especially Marcella Leith and Dave Lambert. We would like to extend our appreciation to Ben Gidley and Mick Gidley for their thoughtful essay which greatly enriches the publication.

The delivery and installation of the exhibition has been handled by Andy Shiel, Juleigh Gordon-Orr and Mikei Hall with their customary expertise, in addition to registrars Alyson Rolington and Sarah Murray. We have also benefited from excellent curatorial support from Inès de Bordas. We are grateful to Rachel Crome who has overseen the framing of all the photographs, and to her colleagues in Paper Conservation, particularly Shona Hunter.

The exhibition has been made possible with the assistance of insurance through the Government Indemnity Scheme. Tate would like to thank the Department for Culture, Media and Sport and Arts Council England for providing and arranging this indemnity.

Thanks are due also to Carolyn Kerr, Amy Thompson, Lorna Robertson, Melanie Greenwood and Gillian Buttimer for their contribution at various stages of the organisation of *Another London*. In addition we are grateful to all those who have contributed in different ways to the many activities that support the exhibition including Kirsteen McSwein, Philip Miles, Helen Beeckmans, Jeannette Ward, Claire Eva, Georgie Ractliffe, Celeste Menich, Jon-Ross Le Haye, Lou Proud, Simon Grant and Mariko Finch.

Helen Delaney
Simon Baker

Biographies

Inès de Bordas
and Helen Delaney

Laure Albin-Guillot 1879–1962
Laure Albin-Guillot was born Laure Meffredi in Paris. In 1901, she married an eminent scientist and the couple worked closely together, observing and photographing microscopic forms: crystallisation, plant cells and animal organisms. In 1922, she received the gold medal in a contest sponsored by the Revue Française de Photographie, and the following year joined the Ecole de Paris alongside photographers such as Emmanuel Sougez. Renowned for her portraits, nudes, still-lifes as well as for her advertising work, Albin-Guillot became a prominent figure of the New Vision in Paris during the 1930s. Microphotography remained a great interest in her career, leading to the publication of her most important work, *Micrographie Décorative* in 1931. Throughout her career, Albin-Guillot experimented with various photographic processes and papers and was one of the first to work with the Fresson print, an elaborate charcoal-based process.

Eve Arnold 1912–2012
Eve Arnold was born in Philadelphia, Pennsylvania, to Russian immigrant parents. She began taking photographs in 1946 while working at a photo-finishing plant in New York, and subsequently studied photography in 1948 with Alexei Brodovitch at the New York School for Social Research. Arnold was first associated with Magnum Photos in 1951 and became a full member in 1957. She moved to England in 1962 and, apart from a six-year interval when she worked in the US and China, she lived in the UK until her death in 2012. Her first major solo exhibition was at the Brooklyn Museum in 1980, when she also received the National Book Award for *In China*. In 1996, *Eve Arnold: In Retrospective* opened at the Barbican Art Gallery, London. In later years, her many honours and awards included being made fellow of the Royal Photographic Society and elected Master Photographer – one of the world's most prestigious photographic honours – by New York's International Center of Photography.

Ellen Auerbach 1906–2004
Ellen Auerbach was born Ellen Rosenberg in Karlsruhe, Germany. She attended sculpture classes in her native city and in Stuttgart before studying photography under Walter Peterhans at the Bauhaus school in Berlin. In 1929, she founded 'ringl+pit', an advertising and portrait studio, with her friend and fellow student Grete Stern. When Hitler rose to power, the young photographer emigrated with her future husband Walter Auerbach to Tel Aviv. In 1935, she moved to London and worked with Grete Stern on a series of portraits of German poet and playwright Bertold Brecht. By 1937, she and Walter Auerbach had married and moved to the US, settling in New York. There, she began to experiment with new photographic techniques, worked for *Time* as a freelance reporter and taught photography at a junior college. In the late 1950s, she travelled and photographed extensively in Latin America.

James Barnor 1929–
James Barnor was born in Accra, Ghana. After a two-year apprenticeship as a photographer he set up his own portrait studio, called Ever Young, in the Jamestown district of Accra in 1949. In the early 1950s he also began to work as a photojournalist for the newspaper *Daily Graphic*, and *Drum*, the most widely read magazine in Africa at the time, which covered news, politics and entertainment. In 1959, with the help of a government grant, Barnor travelled to the UK to work at a colour-processing plant in Kent before embarking on a photography course at Medway College of Art. He was employed as a photographer in London throughout the 1960s and his portraits included images of such high-profile figures as Mohammad Ali. In 1969 he returned to Ghana to set up the first colour-processing plant in the country. He remained there for twenty-four years, before returning to London where he continues to live. He was the subject of a solo exhibition at Rivington Place, London, in 2010.

Mario de Biasi 1923–
Born in Sois, near Belluno, Italy, Mario de Biasi moved to Milan in 1938. Deported to Germany during the Second World War, he started taking photographs in 1945 with a camera found in the debris of Nuremberg. After his return to Italy, Biasi held his first solo exhibition in 1948, and, in 1953, began a thirty-year collaboration with the magazine *Epoca*. Covering numerous assignments around the world, Biasi recorded major historical events such as the 1956 Hungarian uprising and the Vietnam War. Taking part in exhibitions in various countries, he was the recipient of the Life Achievement Award at the Arles Festival in 1994 and was given the honorific title of Master of Italian Photography by FIAF (the Italian Federation of Photography Associations) in 2003.

Izis [Izraël Bidermanas] 1911–1980
Born Izraël Bidermanas in Tsarist Russia-controlled Marijampole, Lithuania, Bidermanas, who later worked under the name of Izis, left his country in 1930 and worked in a photographic studio in Paris. During the Second World War, he fled occupied Paris for the small town of Ambazac, where he was arrested by the Nazis. He was freed by the French Resistance, which he joined and photographed until the Liberation. Upon his return to Paris, Izis worked as a freelance photographer before joining the french magazine *Paris-Match* in 1949. He collaborated with writers, poets and artists such as Louis Aragon, Colette and Marc Chagall. Throughout the 1950s and 1960s, he produced a series of photobooks, including several with the French poet Jacques Prévert. Together they travelled to London, exploring the city to capture its essence. Their poems and photographs were published under the title *Charmes de Londres* in 1952. Izis came back to London to photograph the coronation of Queen Elizabeth in 1953 and published *Gala Day London* and *The Queen's People*.

Dorothy Bohm 1924–
Dorothy Bohm was born in Königsberg, East Prussia, into a Jewish-Lithuanian family. To escape the threat of Nazism she was sent to finish her schooling in England in June 1939. From 1940–42 Bohm studied photography at Manchester College of Technology, and worked in a portrait studio in Manchester from 1942–5 before opening her own Studio Alexander there in 1946. In 1950 she moved to London, where she continues to live. By the 1950s, Bohm had shifted her focus from portraiture to street photography and throughout the 1950s and 1960s she travelled extensively and took photographs

wherever she went. In 1971, she helped found The Photographers' Gallery in London, and for the next fifteen years was its Associate Director. In 1998 Bohm founded the Focus Gallery for Photography in Bloomsbury, London. Her publications include *World Observed* 1970, *A Celebration of London* 1984, *Egypt* 1989, *Venice* 1992, *Sixties* 1996 and *Inside London* 2001.

Edouard Boubat 1923–99

Born in Paris, Edouard Boubat studied at the École Estienne in the late 1930s and worked as a photogravure printer. During the war, he was called up to serve two years of compulsory labour in a factory in Leipzig, Germany. Upon his return to Paris in 1946, Boubat began taking photographs and was awarded the Kodak Prize the following year. In 1951, the magazine *Realités* gave him his first job as photo-reporter and his work was exhibited for the first time in a group show alongside Robert Doisneau, Izis and Brassaï. Boubat worked for *Realités* until the 1960s, travelling extensively around the world to complete assignments. His work and publications received great acclaim, and won him numerous awards such as the Rencontres d'Arles Book Award (1972, 1977), National Photography Award (1984) and the Fondation Hasselblad Award (1988).

Bill Brandt 1904–83

Bill Brandt was born into an Anglo-German family in Hamburg. Beginning his career as an apprentice to a portrait photographer in 1927 in Vienna, he later worked in Man Ray's Paris studio (1929–30) and began to acquire a reputation as a major photographer in his own right, with night photography becoming a particular specialty. He moved to London in 1933 and Britain became his adopted home. Brandt documented the social extremes of life in Britain, particularly those of the capital city. In 1936 he published *The English at Home*, which highlighted stark societal contrasts. The publication *A Night in London* followed two years later. Brandt also began to contribute to magazines such as *Lilliput* (1939–45), *Picture Post* and *Harper's Bazaar*. After the Second World War he focused on portraiture, landscape and the nude. In 1975 he curated *The Land* exhibition for the Victoria & Albert Museum, London.

Exhibitions of his own work include Museum of Modern Art, New York (1948), Hayward Gallery, London (1970), Photographers' Gallery, London (1974), Victoria & Albert Museum (1984) and Barbican Art Gallery, London (1993).

Henri Cartier-Bresson 1908–2004

Born in Chanteloupe, France, Henri Cartier-Bresson is widely regarded as the father of modern photojournalism. He initially trained as a painter, but in the early 1930s he began taking pictures with a Leica camera and his career as a photographer took off, with his first exhibition in 1933 in New York. As a freelance photographer he travelled extensively, documenting the Communist Revolution in China, the end of the Raj in India, as well as the 1968 Paris riots closer to home. He also came to London to document such events as George VI's coronation (1937) and funeral (1952). Known for his ability to catch what he termed the 'decisive moment', Cartier-Bresson founded the co-operative photojournalist agency Magnum Photos in 1947 with Robert Capa, George Rodger and David 'Chim' Seymour. In 1952 he published his first book, *Images à la Sauvette* (published in English as *The Decisive Moment*). From 1968 he began to focus more on drawing and painting than on photography. In 1970 he married the photographer Martine Franck, who continues to direct the Fondation Henri Cartier-Bresson in Paris, a space dedicated to photographic exhibitions founded in his memory.

Hans Casparius 1900–c.1985

Born in Berlin, Hans Casparius developed an interest in photography while he was training to be an actor. He began to work as a stills photographer for films in the late 1920s. From 1930 he travelled extensively on photographic assignments for German and Austrian newspapers. He visited London briefly in 1930, where he documented street life in the capital, returning there in 1937, this time as a refugee from Nazi Germany. He settled in the city and opened the first studio to specialise in commercial colour photography. After the Second World War, Casparius focused on documentary filmmaking, while continuing to take photographs.

Horacio Coppola 1906–2012

Born in Buenos Aires to a family of Italian origin, Horacio Coppola was introduced to photography by his brother Armando. In 1929, Coppola founded the first Cine Club in Buenos Aires and his photographs illustrated the book *Evaristo Carriego* by his friend Jorge Luis Borges. The following year, Coppola travelled around Europe, where he acquired a Leica camera and dedicated himself to photography. From then on, he photographed his native city relentlessly, recording its cultural, architectural and urban evolution. In 1932, he returned to Europe, and studied photography at the Bauhaus, under the direction of Walter Peterhans, attending classes until the school's closure in April 1933. At the Bauhaus, he also met the photographer Grete Stern, whom he later married. In 1934 Coppola and Stern moved first to Paris and then to London. Coppola recorded London's city life and made a 16mm film, *A Sunday on Hampstead Heath*. In 1936, the couple returned to Buenos Aires and set up a photographic studio together.

Bruce Davidson 1933–

Born in Oak Park, Illinois, Bruce Davidson began taking photographs as a child. After studying photography at Rochester Institute of Technology and Yale University, he was drafted into the army and stationed near Paris, where he met Henri Cartier-Bresson, one of the founders of the photographic agency Magnum Photos. After he left military service, Davidson worked as a freelance photographer for *Life* magazine, and in 1958 became a full member of Magnum. In the following years he produced important bodies of work, including 'The Dwarf', 'Brooklyn Gang' and 'Freedom Rides'. With the help of a Guggenheim fellowship in 1962 he produced a powerful series of photographs documenting the Civil Rights movement in the US. In 1970 he published *East 100th Street*, which documented the dire social conditions in East Harlem and shocked contemporary critics. He produced the book *Subway* in 1980, which caught the atmosphere of New York's graffiti-strewn subterranean train system. Davidson currently lives in New York and continues to produce new work.

Lutz Dille 1922–2006

Lutz Dille was born in Leipzig, Germany. He began an apprenticeship with a photographer upon leaving school, but was soon conscripted by the army to fight in the Second World War. Between 1947 and 1951, he attended photography courses at the Academy of Art in Hamburg. In 1951 he emigrated to Canada, where, in 1958, a journalist at the Canadian Broadcast Corporation (CBC) saw a series of photographs that Dille had taken in Paris in 1951 and decided to animate them into a short film for television. This led to numerous freelance assignments for the CBC over many years, and allowed Dille the freedom, between commissions, to travel and take photographs throughout Europe, the US and Latin America. By the late 1960s he was working in film as well as photography, particularly in the area of social documentary. Dille returned to Europe in 1980, living in Wales until 1985, where he taught filmmaking at Newport College of Art, Gwent. He then moved to the south of France, where he lived until his death in 2006.

Elliott Erwitt 1928–

Born in Paris to Russian parents, Elliott Erwitt spent his childhood in Milan and immigrated to the US with his family in 1939. Living in Hollywood as a teenager, Erwitt worked in a commercial darkroom and studied photography at Los Angeles City College. In 1948, he moved to New York, where he met Edward Steichen, Robert Capa and Roy Stryker; they liked and encouraged his work. Erwitt travelled to France and Italy in 1949, taking pictures with his Rolleiflex camera, and a year later was called up for military service; he undertook various photographic duties while serving in a unit of the Army Signal Corps in Germany and France. In 1953, Erwitt was invited by Robert Capa to join Magnum Photos and, from 1968, served as Magnum's president for three years. While continuing his work as a photographer, Erwitt started making films, producing several noted documentaries in the 1970s as well as comedy films for Home Box Office in the 1980s. Erwitt continues to publish and exhibit his work around the world.

Martine Franck 1938–
Martine Franck was born in Antwerp, Belgium, and grew up in the US and UK. She studied Art History at both the University of Madrid and at the École du Louvre in Paris. In 1964 she started working at *Time-Life* in Paris as an assistant to the photographers Eliot Elisofon and Gjon Mili, after which she was employed as an independent photographer by such publications as *Life*, *Fortune*, *Sports Illustrated*, the *New York Times* and *Vogue*. Franck joined the Vu Photo Agency in 1970, and later co-founded the Viva agency in 1972. In 1983 she undertook work for the French Ministry for Women's Rights and in that same year became a full member of Magnum Photos. Franck is particularly known for her sensitive photographs of the elderly, many of which are brought together in her publication *Le Temps de Vieillir* 1980. In 1993 she travelled to Tory Island, off the northwest coast of Ireland, where she documented the daily life of a traditional Gaelic-speaking community. Later projects include photographing Buddhist Tibetan children in India and Nepal.

Robert Frank 1924–
One of the most influential living photographers, Robert Frank was born in Zurich and began taking photographs in 1942 at the age of eighteen. He emigrated to New York City in 1947, where he was soon hired as a fashion photographer for publications such as *Life*, *Fortune* and the *New York Times*. Finding the work frustrating and unsatisfying, Frank abandoned it after a year and for the next six years he travelled extensively in Peru, Bolivia and throughout Europe. He made several trips to London in the early 1950s and lived there with his family during the winter of 1951–2. His photographs from the period show his interest in the extremes of the English class system. He returned to New York in 1953 and later spent two years, funded by a Guggenheim Fellowship, travelling around the US taking photographs, which resulted in his acclaimed book *The Americans* 1958. Frank later shifted his focus to film-making, only returning to photography in the 1970s with work that was informed by his personal life.

Leonard Freed 1929–2006
Born in Brooklyn, New York, to Jewish parents of Eastern European descent, Freed took up photography in 1953. In 1954, after trips through Europe and North Africa, he returned to the US and studied at Alexey Brodovitch's 'design laboratory'. He moved to Amsterdam in 1958 and photographed the Jewish community there. Freed's Jewish heritage has been a lifelong theme and he has documented Jewish communities in many parts of the world, including London. From 1961 onwards he worked as a freelance photographer and travelled widely, documenting the American Civil Rights movement (1964–5), events in Israel (1967–8), the Yom Kippur War (1973) and the New York City police department (1972–9). His publications include *Leonard Freed's Germany* 1971, *Police Work* 1980 and *Leonard Freed: Photographs 1954–1990* 1992.

René Groebli 1927–
Born in Zurich, Switzerland, René Groebli studied photography there with the renowned Swiss master Hans Finsler before completing formal studies as a documentary film cameraman in 1948. He then opened his own photography studio and embarked on a career in advertising and industrial photography. In 1949, Groebli published a landmark photo essay on the French steam railways, 'Rail Magic', which received much critical acclaim. Throughout the following decade he worked as a photojournalist, covering assignments for magazines such as *Life* and *Picture Post*, as well as for the London branch of photography agency Black Star. In 1954, he published another important photo-essay – 'Eye of Love' – and later concentrated on various experiments with colour photography. Groebli's work was showcased in various important international exhibitions, including the first Subjective Photography exhibitions in Saarbruken (1951, 1954) and a retrospective of his work at the Museum of Modern Art in Zurich (1999).

Ernst Haas 1921–86
Born in Vienna, Austria, Ernst Haas was noted for his innovative colour photography. In 1941 he began to study photography at the Graphic Art Institute in Vienna, but left after one

semester, although he continued to take photographs. In 1949 he began to work for *Heute*, an illustrated magazine published by the United States Information Agency in Munich. His photographs of Austrian prisoners of war returning home drew international acclaim, and Haas became, with Werner Bischof, one of the first two photographers invited to join Magnum Photos by its founders. He later moved to New York and in 1953 *Life* published his *Images of a Magic City*, a major colour photo-essay on the city that he had made his home. Throughout the 1950s Haas developed his colour photography and in 1962 the Museum of Modern Art in New York presented a solo exhibition of his colour work. He also shot film stills and was hired in 1964 by film director John Huston to direct a sequence for his film *The Bible*. Haas won the Hasselblad Award in 1986.

Emil Otto Hoppé 1878–1972
Emil Otto Hoppé was one of the most celebrated photographers of the Edwardian era, whose subjects ranged from the English upper classes to Native Americans. Born into a wealthy family in Munich, Germany, he moved to London in 1902, where he initially worked for Deutsche Bank, while also taking up photography as a hobby. He later abandoned his banking career and opened his own portrait studio. Within a few years he had established an international reputation for photographing eminent figures from the worlds of literature, politics and the arts. In 1910 he had his first solo exhibition at the Royal Photographic Society and in 1912 was naturalised as a British citizen. Hoppé also documented the lives of working-class Londoners and published numerous photographic books on London. His extensive travels in search of new subjects took him to, among other places, the US – where he spent time with Native Americans – Cuba, Africa, Jamaica, Australia, New Zealand, Japan and Europe.

Neil Kenlock 1950–
Neil Kenlock was born in Port Antonia, Jamaica. He came to live in London in 1963 at the age of twelve to join his parents, who had settled in the city over ten years earlier. After finishing secondary school, Kenlock worked for commercial studios before establishing

himself as a freelance photographer. In the late 1960s he joined the Black Panther Movement and before long became its official photographer, documenting their marches, protests and prominent campaigners. In 1973 he became the staff photographer on the weekly newspaper *West Indian World*, and in 1979 he co-founded *Root* magazine, the first glossy magazine for Afro-Caribbean Londoners. His focus subsequently turned to radio and he co-founded *Choice FM*, which was the first legal radio station in London devoted to black urban music.

Hannes Kilian 1909–99
Born in Ludwigshafen on Lake Constance, Hannes Kilian attended commercial college before completing a three-year photography course in Switzerland. Following stays in Naples and Paris, he returned to Germany in 1938 to work as a freelance photojournalist and was conscripted as a war reporter in 1941. Upon his return, Kilian resumed his activity as a freelance photographer, documenting the post-war period and, despite a ban on taking photos, made spectacular pictures of bomb damage in Stuttgart in 1944; he also recorded the history of Berlin before and after the Wall. Kilian travelled around the world and his work was published in magazines such as *Time*, *Picture Post*, *Stern* and *Vogue*. In the 1960s, Killian shifted attention to capturing movement and established himself as a ballet and theatrical photographer; his photographs were instrumental in making the Stuttgart Ballet famous worldwide.

Karen Knorr 1954–
Karen Knorr is an American who was born in Frankfurt, Germany. She grew up in San Juan, Puerto Rico, and then finished her education in both Paris and London. From 1977 to 1980 she studied at the University of Westminster and then completed an MA degree at the University of Derby. Her work emerged out of debates in cultural studies in the late 1970s and early 1980s about the politics of representation. During this time, having settled in London, she made series of works such as *Belgravia* 1979–81, which combined image and text to highlight the aspirations and lifestyle of a privileged minority living in one of the most affluent parts of London, and *Gentleman* 1981–3, in

which she again used text with her images, taken in gentlemen's clubs in central London. More recently, Knorr's work has explored the Rajput and Mughal cultural heritage of India. She is currently Professor of Photography at the University for the Creative Arts in Farnham, Surrey.

Sergio Larrain 1931–2012
Sergio Larrain was born in Santiago de Chile. He initially studied music before taking up photography in 1949, which he pursued alongside studying forestry at the University of California at Berkeley. After attending the University of Michigan at Ann Arbor, he embarked upon travels around Europe and the Middle East and began his life as a freelance photographer. He achieved success quickly, and in 1956 The Museum of Modern Art in New York bought two of his pictures. In 1958 Larrain was awarded a grant by the British Council that enabled him to produce a series of photographs of London taken over the winter of 1958–59. The series impressed Henri Cartier-Bresson and led to him being invited to become a member of Magnum Photos. Larrain subsequently spent two years in Paris working for international titles. In 1961 he returned to Chile when the poet Pablo Neruda invited him to photograph his house. In the late 1960s Larrain encountered the Bolivian guru Oscar Ichazo and almost entirely gave up photography in order to pursue his study of Eastern culture and mysticism.

Jacques-Henri Lartigue 1894–1986
Born in Courbevoie, near Paris, to a wealthy family, Jacques-Henri Lartigue was given his first camera at age seven, and started photographing his domestic circle. Later, he recorded the beginnings of aviation, automobile races and fashionable society events of the Belle Époque. After attending classes at the Académie Julian, Lartigue concentrated on painting and exhibited in various salons in Paris; he worked as an artist and illustrator for most of his life. Although he occasionally published his photographic work in the press or exhibited in group shows, the considerable body of the pictures he produced during the period between 1902 and 1940 remained known only to a very small circle until the 1960s, when a number were published in *Life* magazine. In 1963, at the age of

sixty-nine, he was given a retrospective exhibition at the Museum of Modern Art in New York. His first book, *The Family Album* 1966, followed in 1970 by *Diary of a Century*, brought him international critical acclaim and his work has since been showcased in numerous exhibitions and publications.

Herbert List 1903–75
Born in Hamburg, Germany, Herbert List studied art history and literature at Heidelberg University before joining his father's coffee-importing company. In 1924–8, he began taking photographs while on business trips to South America and the US. His friend, the young photographer Andreas Feininger, introduced him to the Rolleiflex camera in 1930. List developed his own photographic language known as 'fotografica metafisica' (metaphysical photography) by combining his interest in Surrealist artists such as Marx Ernst or Giorgio de Chirico with the Bauhaus's modernist style. By the time he fled Germany in 1936, List had taken up photography professionally, with a 1937 solo show in Paris bringing critical attention. Working in Paris and London, he enjoyed great success with publications such as *Life*, *Vogue*, *Harper's Bazaar* and *Arts et Métiers Graphiques*. In 1951, Robert Capa invited him to work as a contributor for Magnum Photos.

Markéta Luskačová 1944–
Markéta Luskačová was born in Prague, Czechoslovakia. She initially studied Social Science at Charles University, Prague, graduating in 1968, and also attended photography courses at Prague's Film and Television School, part of the Academy of the Performing Arts (FAMU), in order to supplement with photographs her thesis on religious pilgrims in Slovakia. This marked a shift away from academic analysis of communities towards a desire to document them exclusively through photography. In 1970 Luskačová arrived in London, where she continues to live and work. Here, she began to photograph the people of Brick Lane and Spitalfields, a long-term project that documented the area's street markets and immigrant communities. In the late 1970s her focus turned towards the photographing of childhood. Luskačová's exhibitions have included *Pilgrims* at Side Gallery, Newcastle, 1985 and *Photographs of*

Spitalfields, Whitechapel Art Gallery, London, 1991; her work was also included in the exhibition *No Such Thing as Society: Photography in Britain 1968–1987*, Aberystwyth Arts Centre, Aberystwyth, 2008.

Dora Maar 1907–97
Henriette Theodora Markovitch was born in Paris to a Croatian father and a French Mother. She grew up in Argentina before returning to Paris in 1927 to train as a painter, and also attended the École de Photographie; painting and photography would remain central to her practice. Her first series of photographs illustrated Germain Bazin's book on Mont Saint Michel. In the early 1930s, Dora Maar set up a studio in collaboration with set designer and photographer Pierre Kéfer, sharing a darkroom with Brassaï. Maar's photography was encouraged by Emmanuel Sougez, a leading figure of the New Vision movement in photography, and this influence can be seen in her use of daring angles, plunging perspectives and photomontage.

Felix H. Man 1893–1985
Felix H. Man was born in Freiburg im Breisgau, Germany. He is considered to be one of the pioneers of photojournalism, developing the combination of text and image that later became known as the photo-essay. Initially a student of Art History at Freiburg University, Man began to develop an interest in photography when, drafted into the German army during the First World War, he made photographs of the trenches of the Western Front. He subsequently worked as a layout artist and photographer for the news agency DEPHOT (Deutscher Photodienst), and went on to produce over a hundred photo-essays between 1929 and 1932 for *Münchner Illustrierte Presse* and *Berliner Illustrierte Zeitung*, most notably 'A Day with Mussolini' in 1931. In 1934, due to the rise of Nazism, Man moved to London, where he lived for the rest of his life, becoming a naturalised British citizen in 1948. In the same year he arrived he co-founded the *Weekly Illustrated* and later worked for both the *Daily Mirror* and the *Picture Post*. During the 1950s Man's focus turned towards collecting artists' lithographs and he became an important collector in this field. He then went on to

become a commissioner and publisher of prints by contemporary artists.

Jean Moral 1906–99
Born in 1906 at Marchiennes, France, Jean Moral moved to Paris in 1925 and worked as a graphic designer and photographer for the publishers Léon Ullman and Alfred Tolmer. Moral later experimented with the possibilities of the photographic medium and its processes, using multiple exposures, photograms and solarisations. His graphic, sometimes abstract compositions are imbued with the modernist influence of the New Vision movement. During the 1930s, Moral's work was widely exhibited in Paris, alongside the likes of Laure Albin-Guillot, Brassaï, Germaine Krull, Man Ray and André Kertész. French poet and artist George Hugnet admired Moral's images, especially those of his wife Juliette, and included them in many of his Surrealist collages. In 1933, Moral took up fashion photography and accepted a contract with the magazine *Harper's Bazaar*, for which he worked until 1952 along with Hungarian-born photographer Martin Munkácsi. Moral also completed numerous assignments for magazines such as *Paris-Match*, *Paris-Soir* and *VU*.

Inge Morath 1923–2002
Born in Graz, Austria, Inge Morath worked initially as a translator and journalist, becoming Austrian editor for *Heute*, an illustrated magazine published by the United States Information Agency in Munich. She collaborated with photographer Ernst Haas as a writer-photographer team to produce articles for *Heute*. On the strength of this work she was invited by Robert Capa to join the newly founded Magnum Photos in Paris, where she worked as an editor. A short marriage to an English journalist prompted a move to London in 1951. In the same year Morath began taking photographs herself, embarking on an apprenticeship with Simon Guttman, an editor for *Picture Post*. Returning to Paris in 1953, Morath was invited to join Magnum Photos, this time as a photographer, first as an associate and then in 1955 as a full member. Between 1953 and 1954 she was an assistant to Henri Cartier-Bresson, and from 1954 worked independently, travelling extensively in Europe, North Africa

and the Middle East. Morath published more than thirty monographs during her lifetime. In 1962 she relocated to the US, where she remained until her death in 2002.

Milon Novotny 1930–92
Born at Stetovice in Moravia, Czech Republic, Milon Novotny took his first photographs in 1950 and was strongly influenced by the work of two leading Czech photographers, Josef Sudek and Jirí Jenicek. Novotny documented local country markets throughout the Czech Republic and had his first exhibition in 1954. The weekly magazine *Kultura* published some of his photographs in 1957 and marked the beginning of a long-lasting collaboration with the press of his native country; he recorded major historical events such as the Prague Spring in 1968. Regarded as a pioneer of humanist photography in the Czech Republic, Novotny received many exhibitions in Czech Republic and his work was included in various group shows throughout Europe.

Irving Penn 1917–2009
Born in Plainfield, New Jersey, Irving Penn studied design with Alexey Brodovitch at the Philadelphia Museum School of Industrial Art from 1934 to 1938. He worked as an illustrator for *Harper's Bazaar* and as an advertising director for Saks Fifth Avenue before taking up photography professionally in the early 1940s. As a staff photographer for *Vogue* magazine, he shot his first cover image for the October 1943 issue. His photographic career spanned more than six decades, during which he created innovative fashion, still-life and portrait studies, and was instrumental in the development of a distinctive style whereby subjects were photographed against a neutral background. In 2009, the J. Paul Getty Museum exhibited in its entirety Penn's *Small Trades* series, his most extensive body of work, which was made in London, Paris and New York between 1950 and 1951.

Marc Riboud 1923–
Born in Lyon, Marc Riboud took his first pictures at the 1937 Great Exhibition in Paris with a small Vest-Pocket Kodak camera given to him by his father. Riboud was an active member of the French Resistance during the Second World War and by 1951, after a brief post-war career as an engineer, he had decided to devote himself to photography. Following time spent in New York, Riboud moved to Paris in 1952, where he met two of the founders of Magnum Photos, Henri Cartier-Bresson and Robert Capa, who invited him to become a member of the agency. In 1953, *Life Magazine* published his famous photograph, 'Painter on the Eiffel Tower'. Acting on Capa's advice, in 1954 Riboud came to London, which he photographed extensively. He travelled all over the world and in 1957, was one of the first European photographers to go to China; he later documented both sides of the conflict in Vietnam. Elected European Vice-President of Magnum in 1959 and President in 1976, Riboud continues to publish and exhibit his work internationally.

Oliver Richon 1956–
Born in Lausanne, Switzerland, Oliver Richon studied Film and Photographic Arts at the Polytechnic of Central London, where he was taught by Victor Burgin, graduating in 1980, and then earning an MPhil in 1988 for a project entitled 'Exoticism and Representation'. Like his collaborator on the *Punks* series, Karen Knorr, his work was rooted in the debates around the politics of representation that were prevalent at the time. Richon settled in Britain, teaching Photographic Studies at the Derby School of Art from 1985 to 1993 and at the University of Westminster from 1993 to 1997. He has been Head of Photography at the Royal College of Art since 1997.

Willy Ronis 1910–2009
Born in Paris to East-European Jewish immigrants, Willy Ronis worked in his father's studio, helping mostly in the darkroom. On the death of his father in 1936, Ronis sold the family business and set up as a freelance photographer, doing commercial work as well as documenting Paris in the rise of the Popular Front. During the War, Ronis fled south to Vichy France and spent a year with a travelling theatrical troupe. After his return to Paris, he joined the Rapho photo agency alongside photographer and friend Robert Doisneau, recording the psychological and physical reconstruction of post-war France. In 1947, he was awarded the Kodak Prize and was included in the 1951 major exhibition curated by Edward Steichen at the Museum of Modern Art in New York, *Five French Photographers*. From the 1960s to the end of the 1980s, Ronis lived in Provence and taught at the School of Fine Arts in various places including Avignon, Aix-en-Provence and Marseille.

Ivan Shagin 1904–82
Born in a village near Moscow, Ivan Shagin began his career as a sailor aboard a Volga steamer, but in 1924 returned to Moscow to work in a store. He had taken up photography as a hobby in 1919 and under the influence of *Soviet Photo* magazine started taking photography courses. Soon, Shagin gave up on his trade career to become a professional photo reporter. In 1928, he made a famous photograph of Maxim Gorky returning from Italy to the USSR, and in 1933, became special photo correspondent for the main national youth newspaper *Komsomolskaya Pravda*, where he worked until 1950. Shagin used glass plates and an old wooden camera to capture his images and, early on, adopted close-ups and daring angles characteristic of Aleksander Rodchenko's photographs. By the mid-1930s, he was recognised as one of the leading photojournalists in the Soviet Union and his images, showcased in major magazines as well as international exhibitions, are regarded as some of the greatest records of the Soviet epoch.

Jeanloup Sieff 1933–2000
Born in Paris to parents of Polish origin, Jeanloup Sieff took up photography upon receiving a Photax plastic camera for his fourteenth birthday. After studying photography in Paris and later in Switzerland, he had his first photographs published in *Photo Revue* in 1950. Sieff began working as freelance photographer in Paris in 1954, and a year later turned to fashion photography. He joined Magnum Photos in 1958 and took assignments in Greece, Turkey and Poland. In the 1960s, Sieff moved to New York and many of his works, for both editorial features and advertising campaigns, were included in fashion magazines such as *Harper's Bazaar*, *Vogue* and *Esquire*. Sieff won a number of awards, including the Prix Niépce in 1981, and the Grand prix national de la photographie in 1992; his work continues to be exhibited and published worldwide.

Wolfgang Suschitsky 1912–
Wolfgang Suschitsky, who became known as much as a cinematographer and film director as a photographer, was born in Vienna. He was brought up by secular Jewish parents who ran a socialist bookshop and were influential figures in the cultural life of 'Red Vienna'. Suschitsky trained as a photographer in Vienna, and moved to Holland in 1934 before settling in England in 1935, where he joined his sister Edith Tudor Hart. In 1936–8 he produced a celebrated series of photographs of Charing Cross Road with its numerous bookshops. He also documented the lives of the East End poor, as well as the more affluent figures of the West End. In 1937, he worked for Strand Films, as cameraman on the documentaries *Life Begins Again* (1942) and *Hello! West Indies* (1943). He also worked on such films as *No Resting Place* (1951), *Ulysses* (1967) and *Get Carter* (1971). A major retrospective of his work, *An Exile's Eye*, was held at the Scottish National Portrait Gallery, Edinburgh in 2002.

Al Vandenberg 1932–2012
Born to Dutch parents, Al Vandenberg grew up with an English foster family near Boston, USA. After joining the US military and serving in the Korean War, he attended art school in Boston and later in New York. He studied photography with Alexey Brodovitch, Richard Avedon and Bruce Davidson. After a successful career in New York in commercial photography, he moved to London in 1965 and became the creative director of an advertising agency. At around this time he collaborated, as art director, on The Beatles' *Sgt Pepper's Lonely Hearts Club Band* album cover. Towards the end of the 1960s Vandenberg took a break from his commercial work and moved back to the US. He spent time hitchhiking around the US and Canada and found himself part of the hippie generation at the height of 'flower power'. He began photographing the unconventional people he encountered, concentrating on making street portraits that allowed his subjects to be themselves. Vandenberg returned to live in London in 1974 and finally completely abandoned his commercial practice. As well as documenting Londoners throughout the 1970s and 80s, he made street portraits throughout his subsequent travels in South East Asia, China and America.

Laure Albin-Guillot
London, the changing of the guards
c.1930–5
Photograph, fresson print
29 x 22
(no.2)

Eve Arnold
One of four girls who share a flat in Knightsbridge 1961
Photograph, gelatin silver print on paper
24.6 x 16.5
(no.71)

Ellen Auerbach
London 1936, later print
Photograph, gelatin silver print on paper
26.5 x 39.2
(no.23)

James Barnor
Eva, London c.1965, printed 2010
Photograph, gelatin silver print on paper
28.2 x 28.4
(no.66)

Flamingo cover girl Sarah with friend, London c.1965, printed 2010
Photograph, gelatin silver print on paper
28.1 x 28.2

Muhammad Ali training, Earl's Court, London 1966, printed 2010
Photograph, gelatin silver print on paper
28 x 28.3
(no.80)

Mike Eghan at Piccadilly Circus, London c.1967, printed 2010
Photograph, gelatin silver print on paper
28.1 x 28.3
(no.81)

Mario de Biasi
London 1974
Photograph, gelatin silver print on paper
30 x 21.2

London 1975
Photograph, gelatin silver print on paper
30.5 x 23.8
(no.89)

Izis Bidermanas
Man blowing bubbles, Whitechapel, London 1950
Photograph, gelatin silver print on paper
28.6 x 21.9
(no.39)

St James's Park, London 1950, later print
Photograph, gelatin silver print on paper
28.2 x 22.2

Wooden horses, bomb site, Mile End Road, E1 1951, later print
Photograph, gelatin silver print on paper
26.9 x 21.9
(no.37)

London 1951, later print
Photograph, gelatin silver print on paper
27.9 x 21.3

London [undated]
Photograph, gelatin silver print on paper
25.8 x 18.8
(no.38)

Dorothy Bohm
Earlham Street, Covent Garden, London 1960s
Photograph, gelatin silver print on paper
32.5 x 30
(no.64)

Asprey Jewellers, Bond Street, London 1960s
Photograph, gelatin silver print on paper
270 x 256

Petticoat Lane Market, East End, London 1960s
Photograph, gelatin silver print on paper
35.4 x 29
(no.65)

Petticoat Lane Market, East End, London 1960s
Photograph, gelatin silver print on paper
27.9 x 24.4

Market stall, Islington, London 1960s, later print
Photograph, gelatin silver print on paper
29.3 x 19.9

Tower of London 1960s
Photograph, gelatin silver print on paper
23.3 x 29.4

Edouard Boubat
Pool of London 1958
Photograph, gelatin silver print on paper
25 x 37
(no.58)

Bill Brandt

Tattooist's window in Waterloo Road
c.1930
Photograph, gelatin silver print on paper
22.9 x 19.4
(no.6)

Regency Houses, Park Lane, Mayfair
c.1930–9, later print
Photograph, gelatin silver print on paper
34.6 x 22.9

Early morning on the doorstep c.1930–9,
later print
Photograph, gelatin silver print
on paper
37.2 x 29.2
(no.11)

Hatter's window Bond Street c.1931–5,
later print
Photograph, gelatin silver print on paper
32.9 x 28.6

Footsteps coming nearer c.1933–6,
later print
Photograph, gelatin silver print on paper
34.3 x 28.9
(no.9)

Housewife, Bethnal Green 1937,
later print
Photograph, gelatin silver print on paper
34 x 29
(no.10)

Henri Cartier-Bresson

Coronation of George VI, 12th May 1937
1937, later print
Photograph, gelatin silver print on paper
23.9 x 35.4
(no.21)

*Coronation of King George VI,
12 May 1937* 1937, later print
Photograph, gelatin silver print on paper
36 x 24

Hyde Park in the grey drizzle 1937,
later print
Photograph, gelatin silver print on paper
24 x 35.8
(no.20)

*Waiting in Trafalgar Square for the
coronation parade of King George VI* 1937,
later print
Photograph, gelatin silver print on paper
44.7 x 29.7
(no.19)

*The embankment in morning, looking
east from the roof of Temple underground
station. Workers going to offices* 1951
Photograph, gelatin silver print on paper
24 x 35.1
(no.43)

Queen Charlotte's Ball, London 1959,
later print
Photograph, gelatin silver print on paper
44.7 x 30.3

Hans Casparius

Trafalgar Square c.1929–30,
printed 1970s
Photograph, gelatin silver print on paper
19.8 x 18.9
(no.13)

Regents Park, London 1930,
printed 1970s
Photograph, gelatin silver print on paper
20 x 19

London 1930, printed 1970s
Photograph, gelatin silver print on paper
21.5 x 21.5
(no.7)

Portobello Road Market, London 1930,
printed 1970s
Photograph, gelatin silver print on paper
20 x 18.9
(no.5)

Horacio Coppola

London 1934
Photograph, gelatin silver print
on paper
20.4 x 14.4
(no.14)

London 1934
Photograph, gelatin silver print on paper
20 x 15.8

London 1934
Photograph, gelatin silver print on paper
19.8 x 15.4

Hampstead Heath, London 1934
Photograph, gelatin silver print on paper
20.9 x 13.5

Pianist, London 1934
Photograph, gelatin silver print on paper
14.7 x 19.9
(no.15)

London 1934
Photograph, gelatin silver print on paper
20 x 14.5

The Drink for You… 1934
Photograph, gelatin silver print on paper
20.8 x 14.5

Bruce Davidson

Young boy at Paddington Station, London
1956, later print
Photograph, gelatin silver print on paper
32.3 x 47.9
(no.68)

Women with baby carriages 1960,
later print
Photograph, gelatin silver print on paper
31.2 x 48
(no.69)

Girl holding kitten 1960, later print
Photograph, gelatin silver print on paper
46 x 30.8
(no.67)

Scene at a cafe 1960, later print
Photograph, gelatin silver print on paper
32.2 x 47.9

Man holding curry sign 1960, later print
Photograph, gelatin silver print on paper
32.3 x 48

Bus conductor woman with ticket machine
1960, later print
Photograph, gelatin silver print on paper
48.1 x 32.4
(no.73)

Queen's guard marching 1960, later print
Photograph, gelatin silver print on paper
32.3 x 48
(no.70)

Trafalgar Square, London 1960,
later print
Photograph, gelatin silver print on paper
48.1 x 31.1

Bombed out car park 1960, later print
Photograph, gelatin silver print on paper
32.3 x 47.9
(no.63)

Lutz Dille

Untitled 1961
Photograph, gelatin silver print on paper
29.3 x 39.2

Untitled 1961
Photograph, gelatin silver print on paper
19.5 x 24

Untitled 1961
Photograph, gelatin silver print on paper
24.5 x 19.2

Untitled 1961
Photograph, gelatin silver print on paper
19.1 x 24.3
(no.77)

Untitled 1961
Photograph, gelatin silver print on paper
29.2 x 38

Untitled 1961
Photograph, gelatin silver print on paper

19.1 x 24.4
Untitled 1961
Photograph, gelatin silver print on paper
23.9 x 17.6
(no.72)

Untitled 1962
Photograph, gelatin silver print on paper
19.3 x 24.2

Elliot Erwitt

London 1952, later print
Photograph, gelatin silver print on paper
30.9 x 46.2
(no.55)

Eric Ambler, London 1952, later print
Photograph, gelatin silver print on paper
46 x 30.9
(no.41)

Bus Stop, London 1952, later print
Photograph, gelatin silver print on paper
45.6 x 30.7
(no.42)

London 1956, later print
Photograph, gelatin silver print on paper
29.8 x 44.9
(no.62)

London 1974, later print
Photograph, gelatin silver print on paper
31.5 x 47.1

London 1978, later print
Photograph, gelatin silver print on paper
30.8 x 45.6

Hyde Park, London 1978, later print
Photograph, gelatin silver print on paper
45.6 x 30.3
(no.100)

Martine Franck

Princess Anne's Wedding, Parliament Square 1973, later print
Photograph, gelatin silver print on paper
36.1 x 24.2
(no.88)

Chelsea Royal Hospital, London c.1973, later print
Photograph, gelatin silver print on paper
24.1 x 35.9

Greenwich, London 1977
Photograph, gelatin silver print on paper
36 x 24.2
(no.96)

Robert Frank

London 1951
Photograph, gelatin silver print on paper
16.2 x 24.6
(no.41)

City of London 1951, printed 1970s
Photograph, gelatin silver print on paper
23.3 x 34.5
(no.45)

London 1951, printed 1970s
Photograph, gelatin silver print on paper
22.1 x 34.2
(no.44)

London c.1951–2, printed 1990s
Photograph, gelatin silver print on paper
31.4 x 25.5
(no.46)

Hyde Park, London c.1951–2, printed 1990s
Photograph, gelatin silver print on paper
33.2 x 22.2
(no.47)

Leonard Freed

Children at a grocery store, London 1971
Photograph, gelatin silver print on paper
16.3 x 24.1

Students from the Lubavitch Hassidic Jewish community school sports day 1971
Photograph, gelatin silver print on paper
20.2 x 30.8

At a rock festival in Hyde Park 1971
Photograph, gelatin silver print on paper
15.1 x 22.8

Young girl smoking with baby, London 1971
Photograph, gelatin silver print on paper
32.7 x 22.1

Naked man and policeman, London 1971
Photograph, gelatin silver print on paper
22.3 x 33.2
(no.84)

Jewish street scene, London 1971
Photograph, gelatin silver print on paper
22.2 x 32.9
(no.75)

Girls outside the Lubavitch Hassidic Jewish community school, London 1971
Photograph, gelatin silver print on paper
20.3 x 30.8
(no.74)

Father and daughter 1971
Photograph, gelatin silver print on paper
26.1 x 17.4

Man on top of a car on Bayswater Road, London 1973
Photograph, gelatin silver print on paper
25.3 x 20.3

René Groebli
London 1949, later print
Photograph, gelatin silver print on paper
34.5 x 24.8
(no.32)

Tram on Westminster Bridge 1949,
later print
Photograph, gelatin silver print on paper
34.6 x 25.9
(no.33)

Ernst Haas
Hyde Park, London 1953
Photograph, gelatin silver print on paper
19 x 24.9
(no.49)

E.O. Hoppé
*Calmly sitting on the parapets of
her mighty bridges* 1932
Photograph, silver print on paper
13.9 x 9.2
(no.3)

*London Stock Exchange, a typical
young businessman* 1937
Photograph, gelatin silver print on paper
21.3 x 15
(no.24)

Billingsgate Fishmarket, East London
1945
Photograph, gelatin silver print on paper
17.5 x 12.3
(no.28)

Neil Kenlock
Leila Hussain at a demonstration, London
1970, printed 2010
Photograph, gelatin silver print on paper
38.4 x 25.7

Black Panther school bags 1970,
printed 2010
Photograph, gelatin silver print on paper
38.4 x 25.3
(no.87)

The Bailey sisters in Clapham c.1970,
printed 2010
Photograph, gelatin silver print on paper
38.4 x 25.3

'Keep Britain white' graffiti, Balham
1972, printed 2010
Photograph, gelatin silver print on paper
38.4 x 25.3
(no.86)

Demonstration outside Brixton Library
1972, printed 2010
Photograph, gelatin silver print on paper
38.3 x 25.3
(no.85)

Hannes Kilian
London 1955
Photograph, gelatin silver print on paper
30.5 x 23.1

London 1955
Photograph, gelatin silver print on paper
30.5 x 23.7
(no.56)

Piccadilly, London 1955
Photograph, gelatin silver print on paper
28.7 x 23.2
(no.57)

Karen Knorr
Olivier Richon
Roxy 1 from the Punks series 1976
Photograph, gelatin silver print on paper
18.4 x 27.9

Roxy 2 from the Punk series 1976
Photograph, gelatin silver print on paper
28.2 x 18.3

Roxy 4 from the Punks series 1976
Photograph, gelatin silver print on paper
27.8 x 19.3
(no.94)

Vortex 2 from the Punks series 1976
Photograph, gelatin silver print on paper
18.9 x 28.2

Vortex 6 from the Punks series 1976
Photograph, gelatin silver print on paper
18.7 x 28.2

Destroy from the Punks series 1976
Photograph, gelatin silver print on paper
26 x 17.8
(no.95)

Sergio Larrain
London 1959
Photograph, gelatin silver print on paper
13.4 x 19.9
(no.60)

London 1959
Photograph, gelatin silver print on paper
13.4 x 19.9
(no.61)

London 1959
Photograph, gelatin silver print on paper
13.3 x 19.9

London 1959
Photograph, gelatin silver print on paper
13.2 x 19.9
(no.59)

London 1959
Photograph, gelatin silver print on paper
13.2 x 19.9

Jacques-Henri Lartigue
Bibi in London 1926, printed c.1980
Photograph, gelatin silver print on paper
16.9 x 36
(no.1)

Herbert List
Totally blind 1936
Photograph, gelatin silver print on paper
29.9 x 23
(no.18)

The bird, Hyde Park, London 1937
Photograph, gelatin silver print on paper
22.9 x 29.2
(no.22)

Markéta Luskačová
*People around a fire, Spitalfields Market,
London* 1976, later print
Photograph, gelatin silver print on paper
29.5 x 42.8
(no.91)

*People in Knave of Club's pub, Club Row,
London* 1976, later print
Photograph, gelatin silver print on paper
28.5 x 42.7

*Woman and man with bread, Spitalfields,
London* 1976, later print
Photograph, gelatin silver print on paper
42.7 x 28.6
(no.92)

*Man with the chicken, Leyden Street,
London* 1976, later print
Photograph, gelatin silver print on paper
41.5 x 29.3

Petticoat Lane market, London 1977,
later print
Photograph, gelatin silver print on paper
28.6 x 43.2
(no.90)

Street musician, Cheshire Street, London
1977, later print
Photograph, gelatin silver print on paper
42.2 x 30

*Man playing mouthorgan in front of
Christ Church, Commercial Road,
London* 1978, later print
Photograph, gelatin silver print on paper
42.7 x 29
(no.93)

Cafe, Bethnal Green Road, London 1979,
later print
Photograph, gelatin silver print on paper
27.5 x 42.9

Dora Maar
*Pearly King collecting money for
the Empire Day* 1935
Photograph, gelatin silver print on paper
27.3 x 23.5
(no.12)

Felix Man
The lights go up in London 1945
Photograph, gelatin silver print
on ferrotyped paper
18.3 x 25.5
(no.31)

Jean Moral
Flowers in Piccadilly 1934
Photograph, gelatin silver print on paper
28.8 x 22.6
(no.4)

London at night 1934
Photograph, gelatin silver print on paper
30 x 24

London at night 1934
Photograph, gelatin silver print on paper
29.9 x 22.5
(no.8)

Inge Morath
Mrs Eveleigh Nash, The Mall, London
1953, later print
Photograph, gelatin silver print on paper
22.6 x 33.4
(no.48)

Milon Novotny
London 1966
Photograph, gelatin silver print on paper
37.2 x 24.3

Billingsgate Market, London 1966
Photograph, gelatin silver print on paper
32.1 x 21.4

Buckingham Palace, London 1966
Photograph, gelatin silver print on paper
25.5 x 37.6
(no.78)

London 1966
Photograph, gelatin silver print on paper
37.6 x 25.4

East End 1966
Photograph, gelatin silver print on paper
24.9 x 37.2
(no.82)

London 1966
Photograph, gelatin silver print on paper
37.3 x 24.2

London 1966
Photograph, gelatin silver print on paper
37.2 x 24.2
(no.83)

Middlesex Market, London 1966
Photograph, gelatin silver print on paper
25.7 x 39.5
(no.76)

Irving Penn
*Young Cricketer (Adam Roundtree),
London* 1950, later print
Photograph, gelatin silver print on paper
41 x 34.5
(no.34)

Cleaning Women, London 1950, printed
1976
Photograph, platinum-palladium print
on paper
61.1 x 50.9
(no.35)

Marc Riboud
The British Museum 1954, later print
Photograph, gelatin silver print on paper
21.9 x 32.5
(no.51)

London 1954, later print
Photograph, gelatin silver print on paper
30.2 x 45.7
(no.50)

Marble Arch, London 1954, later print
Photograph, gelatin silver print on paper
32.4 x 21.6

Waiting for the bus 1954, later print
Photograph, gelatin silver print on paper
32.5 x 21.9

*One policeman, two unemployed people,
London* 1954, later print
Photograph, gelatin silver print on paper
29.3 x 44.2

London 1954, later print
Photograph, gelatin silver print on paper
29.4 x 44.3

St James Park 1954, later print
Photograph, gelatin silver print on paper
32.4 x 21.6

London 1955, later print
Photograph, gelatin silver print on paper
32.4 x 21.6
(no.52)

London 1955, later print
Photograph, gelatin silver print on paper
32.4 x 21.7
(no.53)

London 1955, later print
Photograph, gelatin silver print on paper
32.2 x 21.6

Willy Ronis
Gaston Berlemont's pub, The French House, Soho, London 1955
Photograph, gelatin silver print on paper
27.5 x 39.6
(no.54)

Ivan Shagin
The poor artist, London c.1945–55
Photograph, gelatin silver print on paper
46.4 x 29.2
(no.25)

Jeanloup Sieff
English Nanny, England 1965, later print
Photograph, gelatin silver print on paper
30.5 x 19.9
(no.79)

Wolfgang Suschitzky
East End, London c.1934
Photograph, gelatin silver print on paper
38.7 x 29

Lyons Corner House, Tottenham Court Road, London 1934, later print
Photograph, gelatin silver print on paper
39.5 x 49
(no.16)

Tower Bridge, London 1934, printed 1998
Photograph, gelatin silver print on paper
29 x 37.2
(no.17)

Bishop's Bridge Road, Paddington, London 1935, printed 1998
Photograph, gelatin silver print on paper
29.2 x 37.2

East End, London c.1936, later print
Photograph, gelatin silver print on paper
35.6 x 29.1

Westminster Bridge, London 1936
Photograph, gelatin silver print on paper
25 x 21.5

Near Monument Station, London 1938, printed 1998
Photograph, gelatin silver print on paper
29.1 x 37.5
(no.26)

Waterloo Bridge builders union meeting, August 1939 1939, printed 1998
Photograph, gelatin silver print on paper
29.1 x 34.8

London, Stepney 1940
Photograph, gelatin silver print on paper
22.5 x 28.2
(no.29)

King's Cross Station, London 1941
Photograph, gelatin silver print on paper
28.7 x 24

Trafalgar Square 1942, later print
Photograph, gelatin silver print on paper
39 x 29.2

View from St Paul's Cathedral, August 1942 1942, printed 1998
Photograph, gelatin silver print
37.5 x 29
(no.27)

V.E. Day, Piccadilly, May 1945 1945, printed 1998
Photograph, gelatin silver print on paper
35.3 x 29.1
(no.30)

Hampstead Heath Fair 1949, later print
Photograph, gelatin silver print on paper
32.8 x 28.8
(no.36)

Festival of Britain 1951, later print
Photograph, gelatin silver print on paper
32.5 x 29

Al Vandenberg
Portobello Road 1974,
from the series *On a Good Day*
Photograph, gelatin silver print on paper
12 x 18

Battersea 1975,
from the series *On a Good Day*
Photograph, gelatin silver print on paper
12 x 18.3

Untitled c.1975–80,
from the series *On a Good Day*
Photograph, gelatin silver print on paper
9 x 14
(no.98)

Untitled c.1975–80
from the series *On a Good Day*
Photograph, gelatin silver print on paper
11.6 x 18.2

Untitled, 1975–80
from the series *On a Good Day*
Photograph, gelatin silver print on paper
12 x 18.5
(no.99)

Untitled c.1975–80
from the series *On a Good Day*
Photograph, gelatin silver print on paper
11.7 x 18.8

Untitled c.1975–80
from the series *On a Good Day*
Photograph, gelatin silver print on paper
11.5 x 18

Untitled [Lemmy] c.1975–80
from the series *On a Good Day*
Photograph, gelatin silver print on paper
9 x 14

Untitled c.1975–80
from the series *On a Good Day*
Photograph, gelatin silver print on paper
18.9 x 11.7
(no.97)

Notting Hill Gate 1976,
from the series *On a Good Day*
Photograph, gelatin silver print on paper
18.2 x 11.9

High Street Kensington 1976,
from the series *On a Good Day*
Photograph, gelatin silver print on paper
9 x 14

Battersea 1976, from the series
On a Good Day
Photograph, gelatin silver print on paper
18.3 x 12